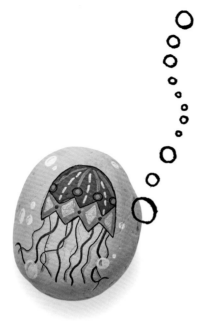

PEBBLE PETS

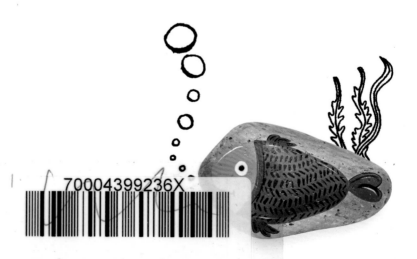

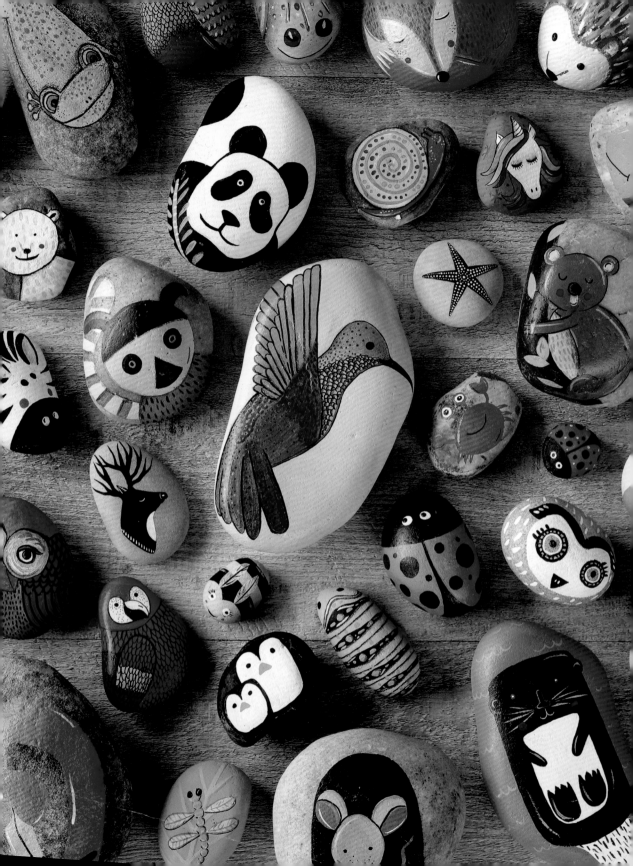

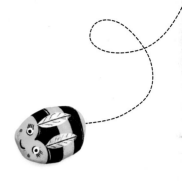

PEBBLE PETS
50 Animal Rock Art Projects

Denise Scicluna

Search Press

A QUARTO BOOK

First published in 2018 by
Search Press Ltd
Wellwood
North Farm Road
Kent TN2 3DR

ISBN:978-1-78221-662-9

10 9 8 7 6 5 4 3 2 1

Conceived, edited and designed by
Quarto Publishing plc, an imprint of
The Quarto Group
6 Blundell Street
London N7 9BH

www.quartoknows.com
QUAR.PETP

Editor: Kate Burkett
Senior art editor: Emma Clayton
Designer: Eoghan O'Brien
Photographers: Dave Burton, Jess
Esposito and Phil Wilkins
Illustrator: Charlotte Farmer
Publisher: Samantha Warrington

MIX
Paper from
responsible sources
FSC® C008047

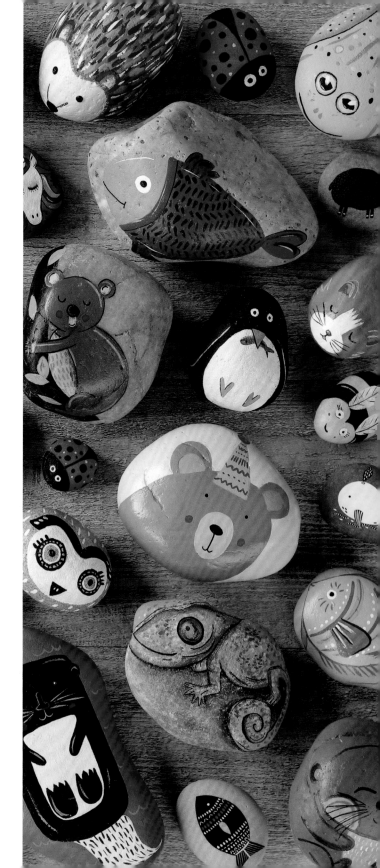

CONTENTS

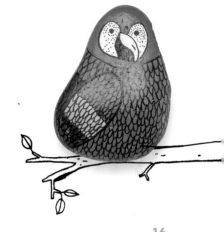

PROJECT SELECTOR

Here are your Pebble Pets at a glance. There are foxes, butterflies, birds and a whole host of other creatures ready for you to create. Turn to your favourite's page to get started right away!

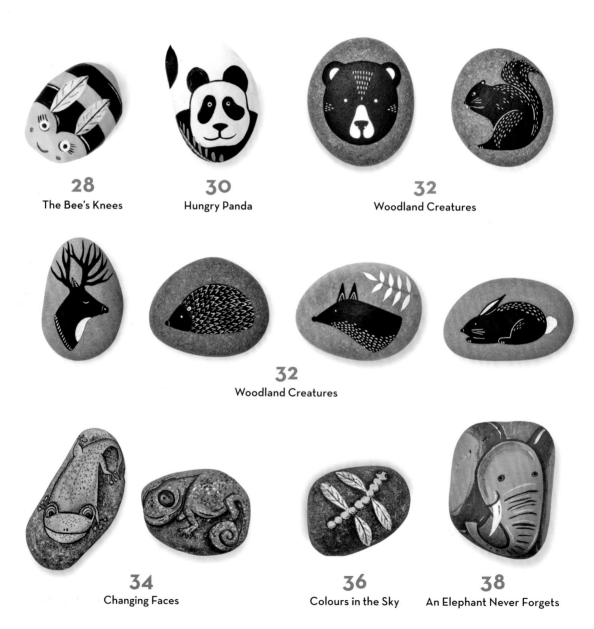

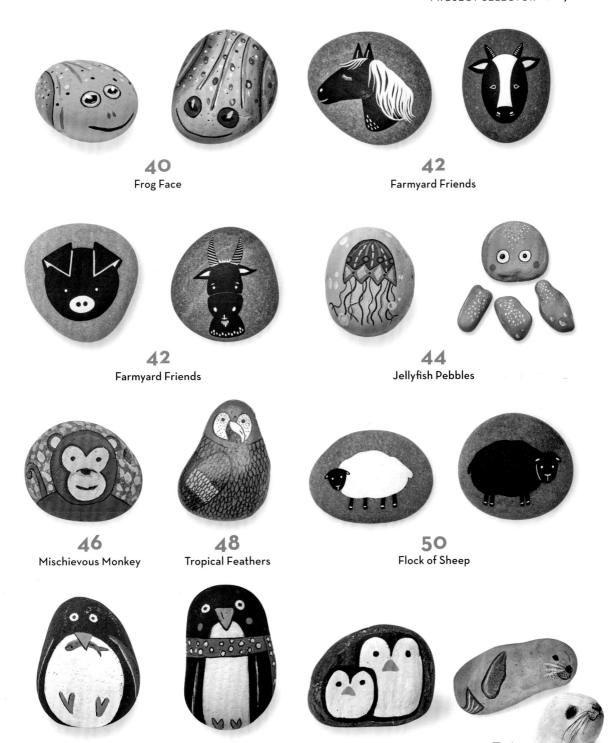

40
Frog Face

42
Farmyard Friends

42
Farmyard Friends

44
Jellyfish Pebbles

46
Mischievous Monkey

48
Tropical Feathers

50
Flock of Sheep

52
March of the Penguins

54
Sealed with a Kiss

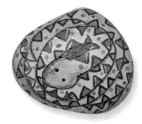

56
Take it Slow

58
Take Flight

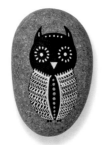

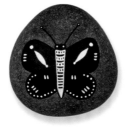

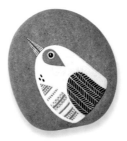

58
Take Flight

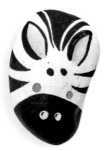

58
Take Flight

60
Slippery Snake

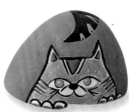

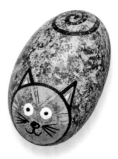

62
Earn your Stripes

64
Cute Kitties

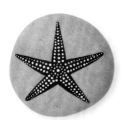

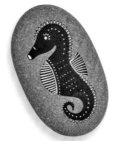

66
Sea Life

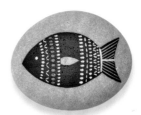

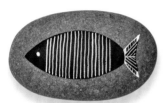

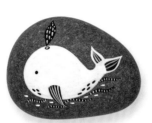

66
Sea Life

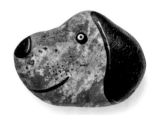

68
A Dog's Life

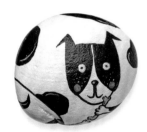

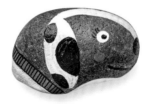

68
A Dog's Life

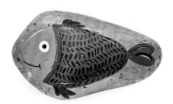

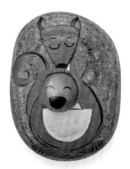

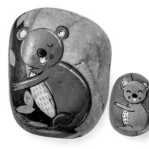

70
Under the Sea

72
Kangaroo and her Joey

74
Climbing Koala

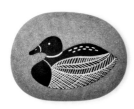

76
Ducks for Luck

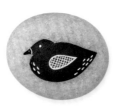

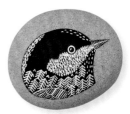

78
Leaping Lemur

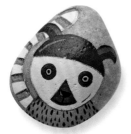

78
Leaping Lemur

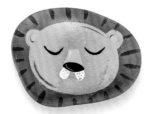

80
The Lion's Den

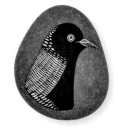

82
Garden Birds

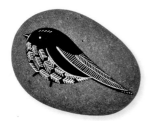

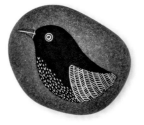

82
Garden Birds

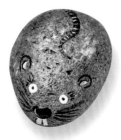

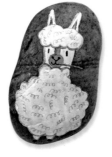

82
Garden Birds

84
Awesome Alpaca

86
The Big Cheese

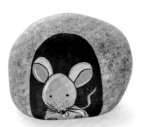

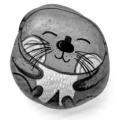

86
The Big Cheese

88
The Original Gangster Otter

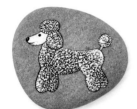

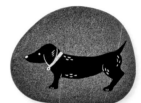

90
Breeds of Dog

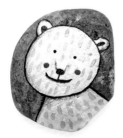

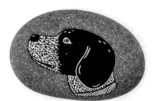

90
Breeds of Dog

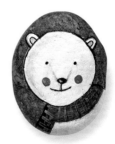

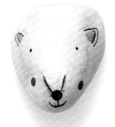

92
Bear Hug

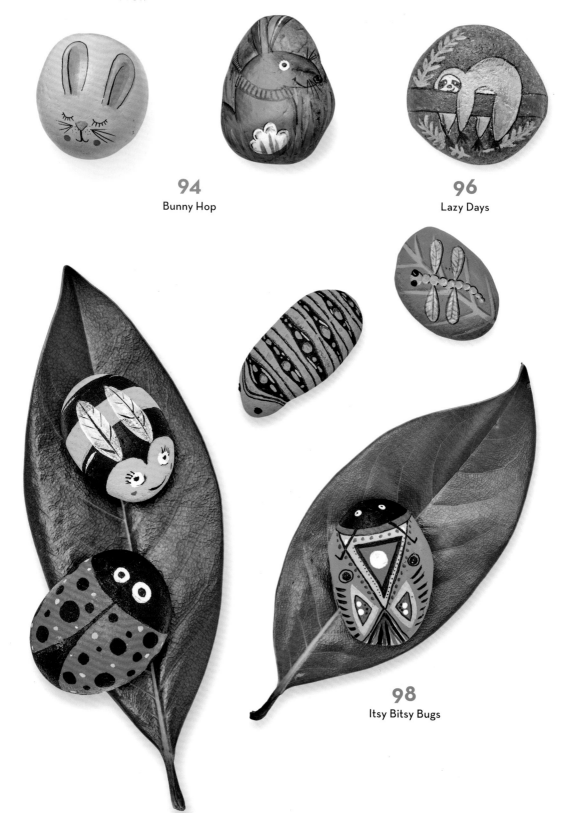

94
Bunny Hop

96
Lazy Days

98
Itsy Bitsy Bugs

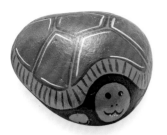

100

Slow and Steady wins the Race

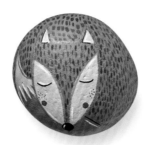
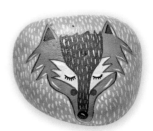

102

Wolf and Fox

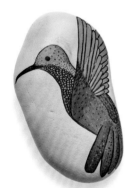
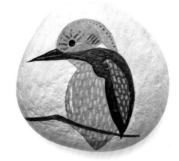

104

Tropical Birds

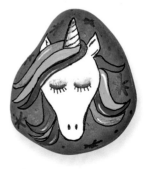

104

Tropical Birds

106

Rainbow Unicorn

WELCOME TO
MY WORLD

If you have bought this book, or it has been given to you as a gift, prepare to welcome imagination, creativity and plenty of animals into your life! This book is a follow-up to my first book, *Rock Art* – with a difference. This time, it is all about animals. Simple step-by-step instructions allow you to transform your pebble into any animal, including birds, insects, fish, reptiles, amphibians and mammals.

The secret to making your perfect pet pebble is to have the right tools and, ideally, a pebble with a shape that resembles the animal you wish to paint. Why not make it more exciting by picking a pebble and letting its shape inspire you? Could it be a seal? Or maybe a snail? There are over 1.3 million species on our planet to choose from!

This book starts with tips on picking your pebbles and then guides you through the projects, all of which can be completed easily in your home. Lastly, you will find that your finished pet pebbles can be used in practical, stylish, fun, educational and decorative ways. Don't worry if you have little or no experience with painting; this book will awaken your imagination to endless rocky and creative possibilities!

Rock art can be particularly fun for kids and is totally enjoyable for adults, too, so let's add some more animals to this planet!

Keep on rocking!

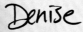

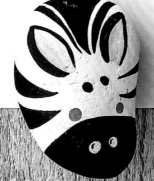

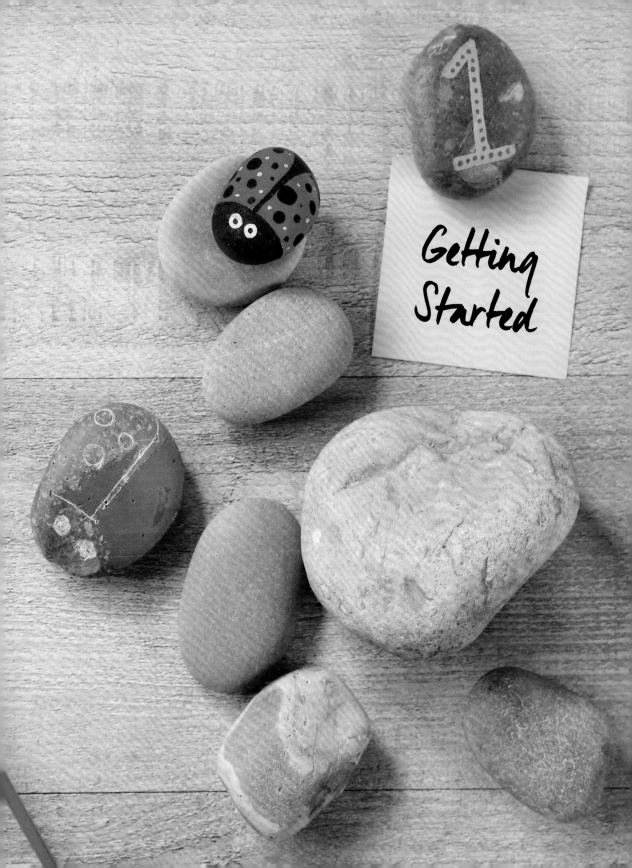

Pebbles and rocks can be found in lakes and rivers, at coasts and beaches, and in your back garden. In this chapter, you will pick up some basic tips and facts about rocks, which will help you find and choose the right pebble for your pet.

Is it a rock or a pebble?

Pebbles are like all other rocks and minerals. To be specific, a pebble is a class of rock, larger than a granule but smaller than a cobblestone. What makes pebbles so beautiful are their various textures and colours. Some have lovely coloured streaks of quartz and other sedimentary rock running through them. The various minerals in pebbles and rocks make them distinct from one another, and unique. Generally smooth, pebbles can also be textured, which is often caused by prolonged contact with seawater.

You can also find inland pebbles along the shores of large rivers and lakes. These river pebbles are formed from river rock, as flowing water washes over particles along the shores. The combination of soil, chemical elements and the speed of the current all impact on the colour and smoothness of river pebbles. The most common colours of river rock are black, grey, green, brown and white.

There are three different types of rock – igneous, sedimentary and metamorphic – and they are all formed in different ways. This means that they all have different appearances and properties, and are found in different places. The most important consideration for you is how a pebble is going to work for your project, and the guide on page 21 will give you some basic information about the different types of rock you may come across.

Not up for hunting?

Don't despair. The great news is that if you don't have the time or the inclination to go out and collect your own rocks, or you're not near to a beach or river, you can still find perfect rocks. Luckily, all kinds of pebbles are available to buy from craft shops, garden centres and online.

If you are ordering pebbles online, make sure you take note of the dimensions so that the size will match what you have in mind. Buying online is very different from scanning the beach and picking the pebbles yourself, as it does not give you the chance to see or feel the pebble and let ideas come to you. However, all online stores have images and descriptions of the types of pebbles on sale. And of course, the major bonus of ordering online is that the stones can be delivered straight to your front door, saving you from lugging heavy rocks around.

When purchasing pebbles, prices will vary depending on what type of pebbles you are ordering; for instance, pebbles with holes pre-drilled in them will inevitably be more expensive. Always check out at least two or three shops before making a decision, as prices can vary. Sometimes prices are lower if you purchase a big bag of pebbles – you might be lucky enough to get a bulk deal. Simply pack away any unused pebbles for another project another time if you do not intend to use the whole bag.

What to look for in a pebble

There are two ways that you can match up a rock with an art project: Essentially, you choose the project first or you choose the stone first. You might already have a certain design in mind, or a certain type of project you want to complete, that will require a specific size or shape of stone. You may have your heart set on painting a dog, zebra or koala, or on creating an animal brooch or a game, and all of these would require a stone with different properties. The challenge is to find just the right stone to be your animal canvas. Try not to be too rigid with your specifications – think about how your animal design could work on various pebble shapes. You can choose to use all of the pebble's surface, including the side and the back, or picture your chosen animal in the centre of your pebble.

If you don't already have your heart set on an animal design, you can simply sit back and let the pebbles inspire you. Remember, there are over one million species on this planet, so there are plenty to choose from.

You do, however, need to keep some general guidelines in mind during your rock hunting. For example, you need to make sure that your pebbles have a smooth surface. Firstly, this will make it easier for you to draw with markers and pens, and your line work will look neater. Secondly, a smooth, painted and varnished surface looks much better and neater than a rough, bumpy surface, so avoid picking up rough-surfaced rocks. Every rule has an exception, though, and a rough, textured stone that has been cleaned and varnished can look wonderful displayed just on its own. Check out the examples shown on the right for some other things to look out for on your hunt for that perfect pebble.

Bringing your project to life

So now that you have found the pebble, what do you do with it? Where do you start? If your pebble is small, you can make use of fine-point markers, which allow you to work in detail to produce beautiful, intricate lines and shapes. You can choose to go for acrylic paints and paint all over your pebble, adding details with markers or a fine paintbrush afterwards. Outlines work beautifully in rock art – create lines and patterns on your painted animals and add shadows to make your design stand out. Use white paint or markers on black pebbles – the effect is remarkable.

Painting pebbles can seem a little overwhelming, especially for those who have never painted before. The following pages will guide you through every step, making

you feel more at ease with painting animals on pebbles. This simple yet effective art offers a world of inspiration, which will hopefully bring ideas and creativity into your home and your life.

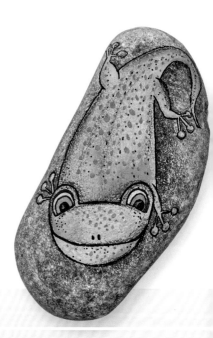

KNOW YOUR ROCKS

Metamorphic Rock

Metamorphic rocks are formed when other rock types are subjected to immense heat or pressure. The movement of the Earth's plates can cause rocks to be buried and squeezed, or molten magma can cause rocks to become super-heated. Rather than melting, minerals in the rocks undergo a chemical change and their crystals become arranged in layers. Examples include slate and marble.

Sedimentary Rock

Formed in a more natural and prolonged way, sedimentary rocks are found on shores or in water, where they have been weathered by older stones. In this weathering process, bits and pieces from older stones start to settle together with other organic materials, such as parts from animals and plants. The pieces are deposited and build up into layers known as sediments, and are then compacted by further layers building up on top. Examples of such rocks are sandstone, chalk, limestone and flint.

Igneous Rock

When rocks melt deep inside the Earth and become molten, this is known as magma. When magma cools and solidifies, igneous rock is formed. Igneous rocks are made up of interlocking crystals in a random arrangement. The more slowly the magma cools, the bigger these crystals will be. Examples of types of igneous rock are basalt, granite and pumice.

THE PERFECT ROCK

Here are some tips about what to look out for when you are searching for your perfect rock.

Opt for smooth surfaces.

Bumps can easily distract from your design, especially if you are using marker pens rather than paint.

Pick the best side.

Look out for the 'right' side of your pebble if you are painting on one side only. Often, one side is more ideal and might have fewer bumps or irregularities than the other.

Interested in creating pebbled jewellery or accessories?

Look out for tiny, smooth pebbles. Small, lightweight pebbles are the best for jewellery, magnets and brooches.

Keep an eye out for families of pebbles.

Some pebbles just seem to go well together, and you might want to undertake a project in which you include all of them, such as a family of animals or a group of ladybirds.

Don't be afraid to pick weird-shaped pebbles.

You might be surprised how they can inspire you! Unusually shaped pebbles can be the ones to bring you the best inspiration.

Get the right shape.

Depending on what you plan to paint, having the right base shape will provide the ideal foundation for your crafted pebble.

Do you plan on designing monochrome pebbles?

Look out for dark and black pebbles – white painted designs will look beautiful on the dark, natural texture, and there is no need to paint a background colour.

Look out for big pebbles if you plan to work on large projects.

Painting a large bear or a giant fish might require a sizeable pebble. Make sure the pebble is steady, heavy, and not bumpy.

Does it stand up?

If you want to paint a standing pebble, test it to see if it can stand. It is a rare find, so treasure it if you find one!

WHAT DO YOU NEED?

The tools below are divided into two categories – the 'must-haves' are the bare essentials needed to paint and decorate your pebbles. The 'other' tools help to transform your pebbles into games, accessories, and home or garden decorations.

MUST–HAVE TOOLS

Paintbrushes (1)

It's good to have a selection of brushes, so that you can make use of fine brushes for outlines and details, and wider ones for painting whole pebbles. Use quality brushes and take good care of them to make sure you always get the best results.

Marker Pens (2)

Available in a variety of colours, marker pens can be used for outlining your animal designs and for adding details. Silver or gold marker pens can add shine to your pebble pet.

Fine Liners (3)

You may find it easier to use fine pens rather than paint to create detailed patterns, especially on smaller pebbles. Just make sure that they are waterproof! If you are drawing over a painted area, make sure that the paint is fully dry first.

White Chalk/Pencil (4)

It is a good idea to outline your design before you paint, and these tools are perfect for the job; use chalk on dark-coloured pebbles and pencil on light-coloured pebbles. You can always rub off any chalk or pencil that is still visible when you've finished painting. Pencils can be used to create shadows – add some to the edges of the wings of a bird or the eyes of a dog.

Varnish (5)

An overall coat of varnish will make your finished pebbles stand out. Most importantly, it acts as protection and stops the paint from chipping.

Acrylic Craft Paint (6)

These are the best paints to use and they come in a wide range of colours. Why not buy just the primary colours, black and white to begin with and use them to mix and make other colours? Acrylic craft paints are reasonably priced and can be found in all arts and crafts stores.

Black 3D Liner Pen (8)

These useful pens allow you to create a 3D 'blob' effect on your pebbles and come in a range of colours. They are ideal for adding eyes, dotted patterns and a bit of texture to your pet pebble.

Mixing Plate (9)

Use a plastic plate to mix and add as many paint colours as you want.

Cup of Water

Keep a cup of water nearby and use it to clean your paintbrushes between paint colours.

Damp Cloth

To clean your pebbles.

Paper Towels

Very useful for wiping any stray paint from your hands, brushes and pebbles, and for quickly cleaning up any mess in your workspace!

Hair Dryer

You can use your hair dryer to speed up the drying process.

OTHER TOOLS

PVA Glue and Super-Glue (7)

Whether you're adding googly eyes, brooch pins, fabric embellishments or smaller rocks to your pet pebble, it's a good idea to have some PVA glue and super-glue at hand.

Sponge

Animals are all about patterns and textures. Use a sponge to apply different layers of paint to your pebble to create an attractive texture.

Brooch Pins

If you want to turn your painted pebbles into brooches or pins, you can pick up brooch pins at craft or jewellery supply stores. The best way to attach a brooch pin to a stone is to first sew the pin to a small rectangle of thick felt. You can then apply super-glue to the piece of felt and securely attach this to the back of your pebble.

Chain/Cord (10)

It's possible to turn small painted rocks into beautiful pendants of your favourite animal. If you plan to do this, you will need a chain, some string or a cord to complete your necklace.

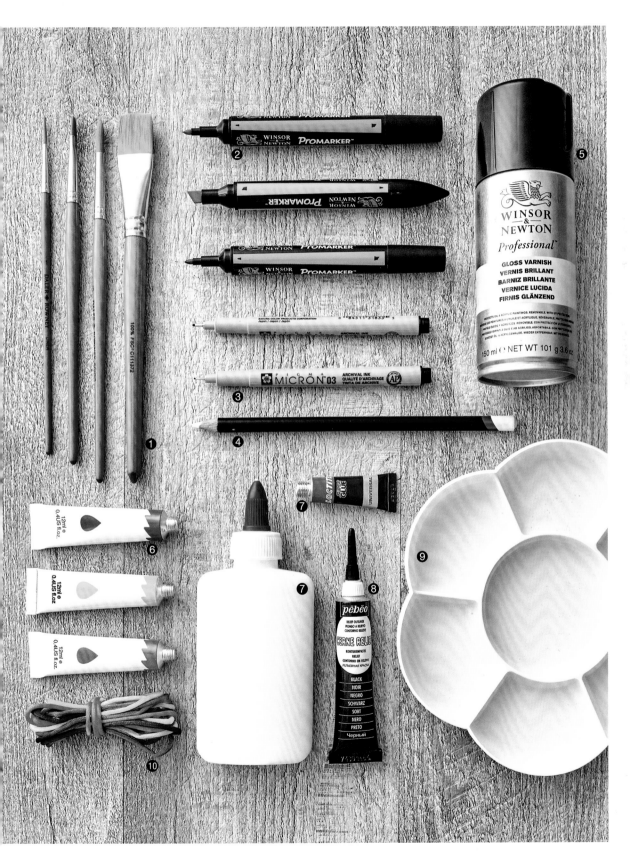

PREPARATION

The absolute first step you need to take when you've chosen your pebble is to clean it thoroughly with a damp cloth and liquid soap. Then you can start to think about working with its shape and laying out your animal design.

SKETCHING YOUR IDEAS

It is well known that sketching beforehand is a good idea – most artists make use of sketching before starting to paint. Similarly, it helps to have at least an idea of what you are about to paint on your pebble.

Sketch your ideas for your animal design in a notebook or on some paper and keep it next to you as a reference. Alternatively, sketch the design directly on the pebble by using chalk or pencil. If you are using light or white pebbles, you can use a pencil to sketch your design. However, try to mark the pebble very lightly, to avoid having visible lines after you paint. If your pebble is darker, chalk will be easier to see. The great thing about using chalk is that you can rub it off with your fingers if you make a mistake or want to start again.

Sketching does not mean creating an exact outline of the idea. The purpose is to have an idea of proportion and use of space on your pebble. It is a time to think about whether you are using the back or sides of the pebble, and how to organise your shapes and lines. Sketch just the basic shapes of your design; do not focus on details, as ideas will start to flow once you get started with the painting. Here are some ideas and tips for those wanting to sketch their own designs. If you feel confident enough, you can easily skip this step and go with the flow of the creative process.

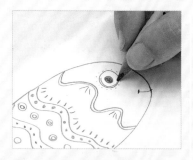

Sketching on Paper
Make a quick sketch of your animal design. Remember, there is no need to go into detail, but you can present your full idea on paper if preferred. Keep the sketch next to you as you work on your rock.

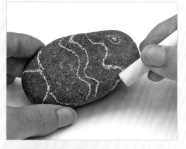

Sketching on Dark Pebbles
Using chalk, sketch your design, focusing on the basic shapes. Use your finger to erase any lines if you need to. It is that easy!

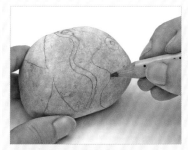

Sketching on Light Pebbles
If your pebble is light-coloured, use a pencil to make light markings of your design. Remember not to press too hard, to avoid having visible lines after you paint your pebble.

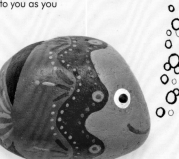

FINISHING TOUCHES

Once you've finished painting your pebble, you might want to varnish it to give it a bit of shine and protection, or to enhance your design by adding shadows.

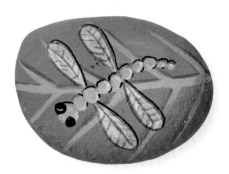

OUTLINES AND SHADOWING

If you want your pebble pet to look as real as possible, you might want to add some shadows. This can be done with pencil or pens or using a lighter or darker shade of paint. If you have done real-life painting, shadows will probably come easily to you.

VARNISHING THE PEBBLE

Just one layer of varnish will make the colours of your pebble stand out. It also protects the pebble and keeps the paint from peeling off. There are three types of varnish: matt, semi-gloss and glossy. They all have the same protective properties, but vary in their final effect: Gloss varnish will make your pebble look shiny, so opt for matt varnish if you want to avoid this. Varnish comes in liquid and in spray form. A spray varnish will make it easier and quicker to cover all sides of the pebble and is highly recommended. If using liquid varnish, you need to use a large paintbrush for an even coverage. It is important to wash your brush after varnishing.

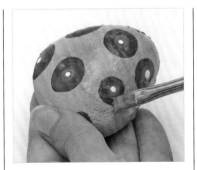

Using Liquid Varnish

When your pebble is complete and the paint is dry, you can apply varnish to one side of your pebble. Allow to dry for a few minutes (a hair dryer is useful here) and then turn your pebble over and varnish the other side.

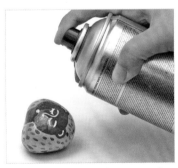

Using Spray Varnish

Spray one side of your pebble, then turn it over and spray the other side. Make sure you cover all areas, including the sides.

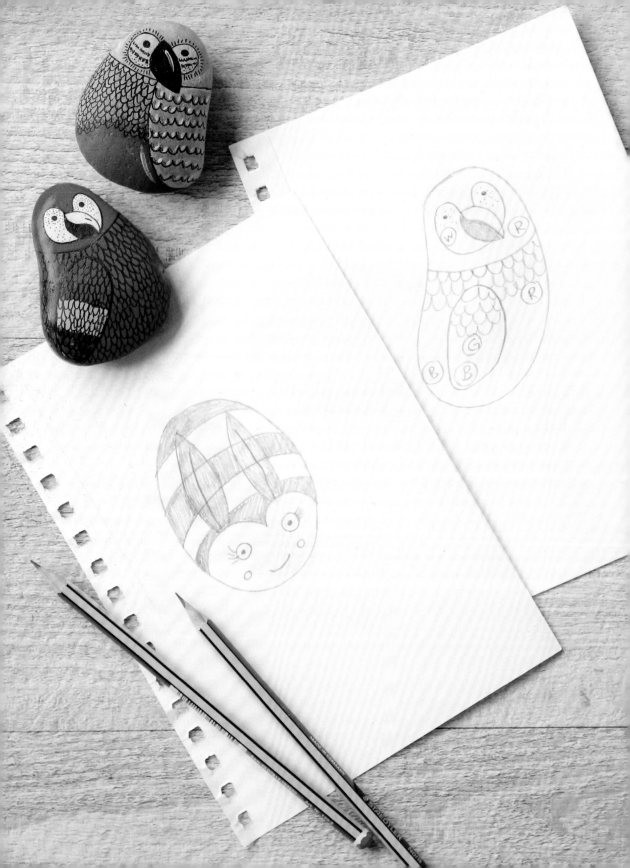

THE BEE'S KNEES

Get a buzz out of painting pebbles with this swarm of bees. The wings can prove a bit tricky, but will really make your designs fly!

YOU WILL NEED

- Round pebbles
- Damp cloth
- Chalk or pencil
- Paintbrushes
- Thin black pen
- Yellow, black, white and red craft paint
- Varnish

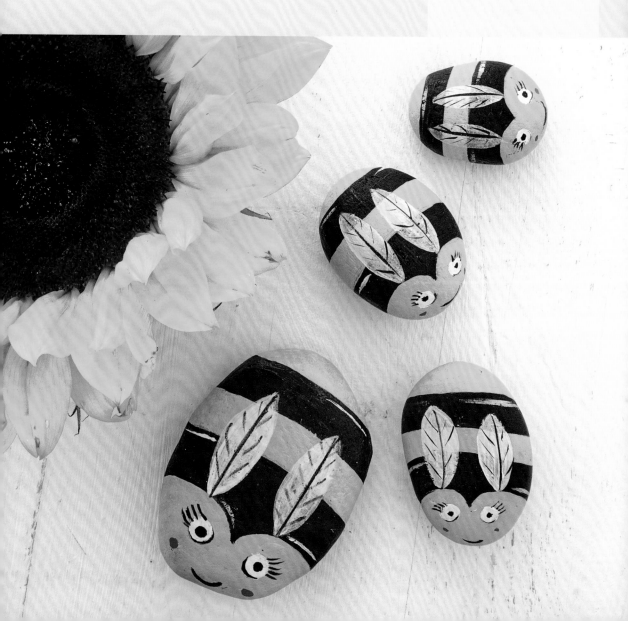

1 Find a roundish pebble and clean it with a damp cloth.

2 Paint your pebble yellow. Add a second layer of paint for a deeper colour, once the first layer is completely dry.

3 Draw four slightly curved lines with chalk or pencil, making sure you leave enough space for your bee's face. Add a triangle shape to the first line – this will give more shape to the face.

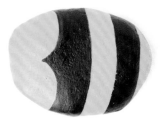

4 Fill in the first and third stripes and the triangle using black paint.

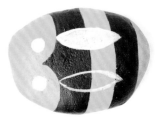

5 With white paint, add a pair of eyes and the outline of the wings. Fill in the wings with a thin layer of white paint – this will create a transparent effect.

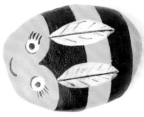

6 Add black dots and eyelashes to the eyes, a small smile to the face and thin black lines over the wings.

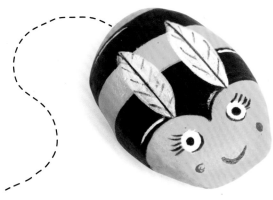

BUZZZZZ

7 For extra cuteness, add two rosy cheeks with red paint. Add shadow effects on the black stripes using white paint. Varnish the pebble once the paint is dry.

HUNGRY PANDA

Grab a chunky, round pebble and get inspired by these cute monochrome bears. They are great animals to colour onto rocks – all you need is black and white paint. Why not add some bamboo leaves, too – for when your panda gets hungry!

YOU WILL NEED

- Large, oval or round pebble
- Damp cloth
- Pencil
- Paintbrushes
- Thin black pen
- White, black, green and yellow craft paint
- Varnish

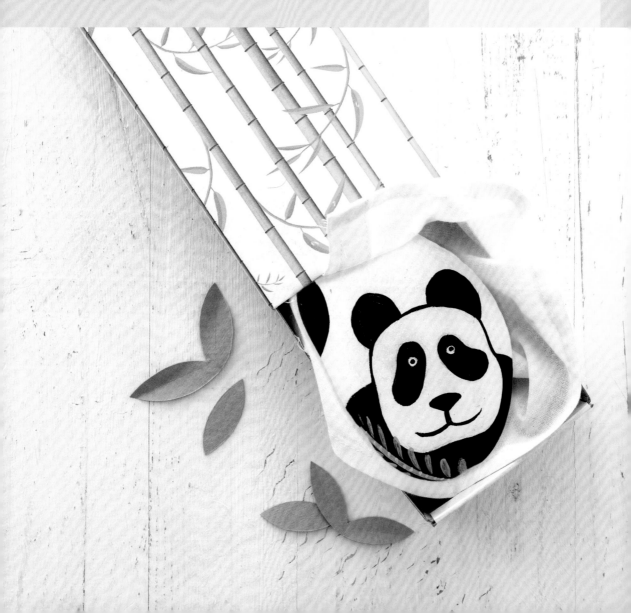

1 Pick a large, oval or round pebble and clean it with a damp cloth.

2 Apply two layers of white paint. Make sure that the first layer of paint is dry before applying the second coat.

3 Sketch a basic shape for the panda face – round ears and curved, circular patches around the eyes. You can add legs, too, depending on the shape and size of your pebble.

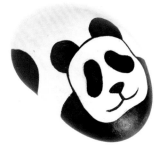

4 Using black paint, fill in the chest, ears, eye patches and legs. Add a nose and mouth and outline the head.

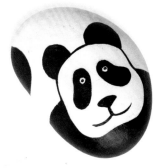

5 Add a pair of eyes inside the two patches, using white paint for the irises and black for the pupils.

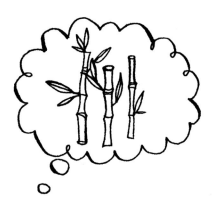

6 Finally, feed your hungry panda by painting a green and yellow bamboo shoot within reach of its mouth. Varnish the pebble once the paint is dry.

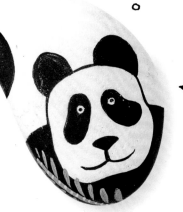

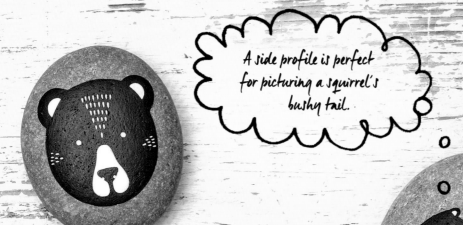

A side profile is perfect for picturing a squirrel's bushy tail.

WOODLAND CREATURES

They're shy and move fast, but furry woodland animals will sit nicely on a pebble in your pocket.

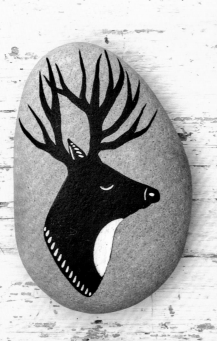

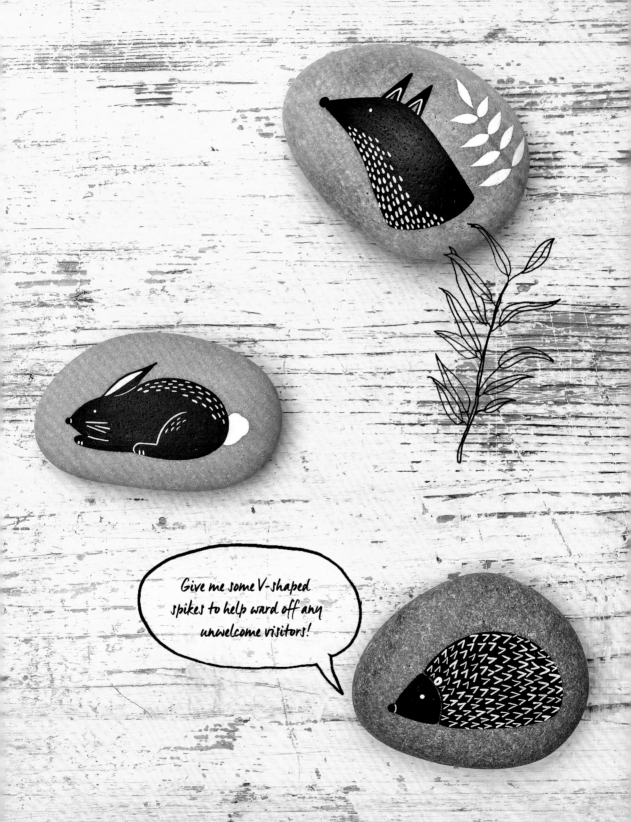

CHANGING FACES

Known to blend in wherever they go, chameleons have beautiful features, colours and textures – just perfect for painting onto pebbles.

YOU WILL NEED

- Large, bumpy, round pebble
- Damp cloth
- Pencil
- Paintbrushes
- Thin black pen
- Bright green, dark green, white and yellow craft paint
- Varnish

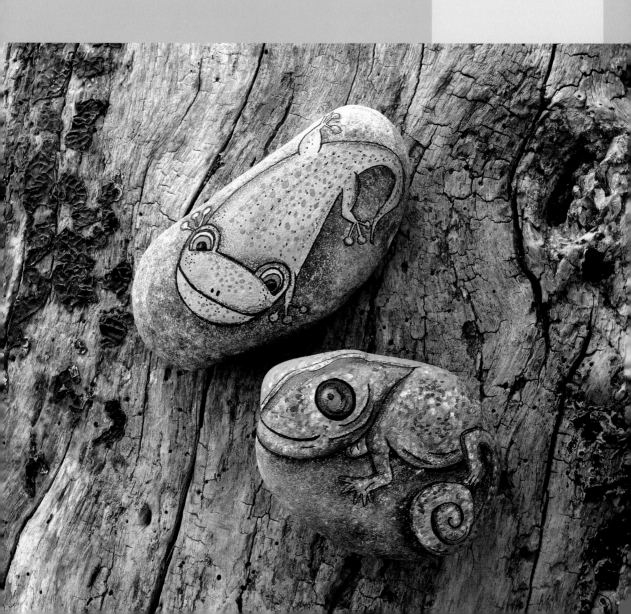

1 Select a large, round pebble, preferably with a bumpy side. Clean the pebble with a damp cloth and sketch the basic body for your chameleon so that it looks as though it is clinging on.

2 Use bright green paint to colour the body. Add a darker circle of green for the eye.

3 Using a small brush, paint white dots all over the body.

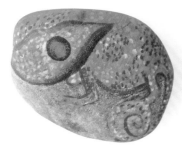

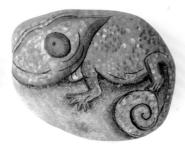

4 Now add dots and shadows using dark green paint. Outline the eye and face.

5 Use a thin black pen to outline the whole body, including the eyes, and the curly tail. Add the mouth and a couple of lines around the eyes and legs.

6 To add more texture, dab yellow dots over the white and green ones, and pencil shading both inside and outside the outline, to make it look as if the chameleon is crawling on the pebble. Varnish your pebble to secure the paint and pencil shading.

This mischievous-looking gecko (opposite, upper left) can be created using a similar technique to the chameleon. Use shades of green and orange, and some pencil shading to create texture.

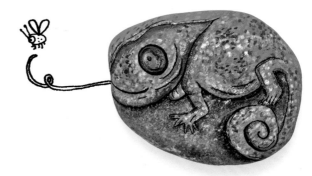

COLOURS IN THE SKY

Dragonflies are dainty and vibrant insects that are easy to paint. This pet pebble will look great in your garden – why not place it in one of your plant pots? You can leave the natural colour and texture of your pebble to show through for contrast.

YOU WILL NEED

- Flat, oval pebble
- Damp cloth
- Chalk
- Paintbrushes
- Pencil
- Thin black pen
- White and light blue/green craft paint
- Varnish

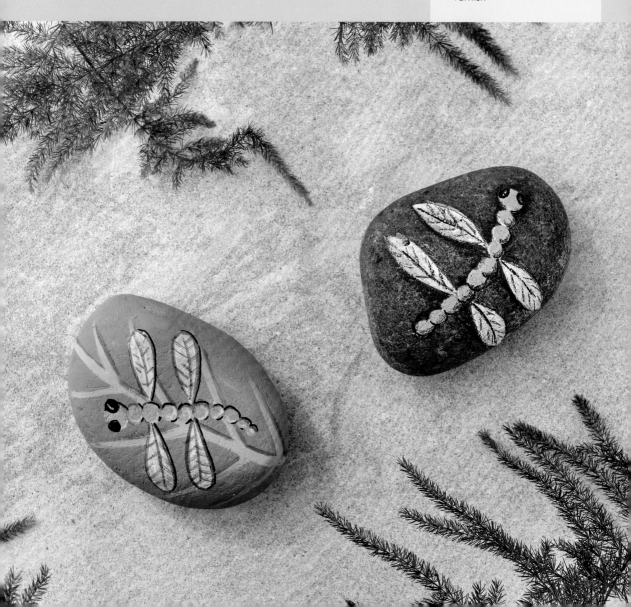

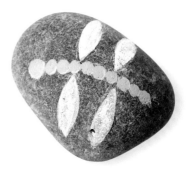

1 Select a flat, oval pebble and clean it with a damp cloth. Use chalk to draw a curved line for the body and four oval shapes for the wings.

2 Following the curved line of the body, and using light blue/green paint, create one big and nine small circles next to each other. The larger circle at one end of the body will be the head.

3 Paint the four wings with a light layer of white paint.

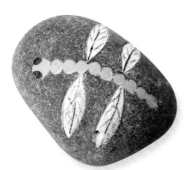

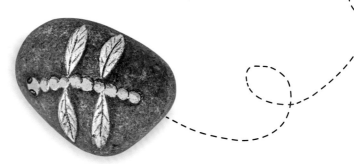

4 Use a black pen or black paint to fill in the wings with very thin lines. Add two black dots to create a pair of eyes on the largest blue/green circle.

5 With a pencil, create shadows on one side of the body and around the wings. Be careful not to smudge the pencil and make sure you varnish your pebble to protect the paint and shading.

Why not use your rock as a leaf for the dragonfly to perch on (opposite, left)?

AN ELEPHANT NEVER FORGETS

Paint one of the largest mammals in the world – including its trunk and rather large ears – on a pebble small enough to fit in your pocket.

YOU WILL NEED

- Large, elongated pebble
- Damp cloth
- Chalk
- Paintbrushes
- Thin black pen
- Light grey, mid-grey, dark grey, pink and white craft paint
- Varnish

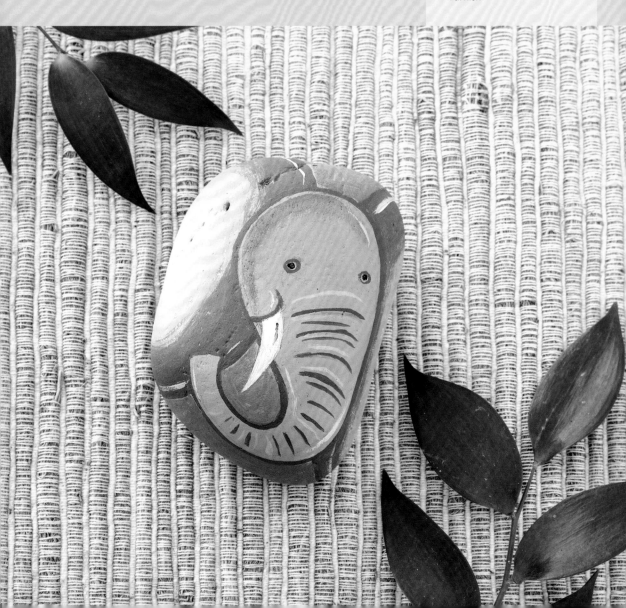

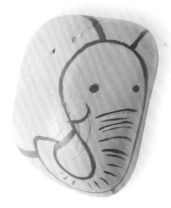

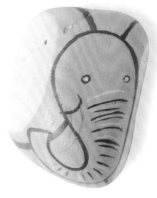

1 Pick a large, elongated pebble and clean it with a damp cloth. Paint the entire pebble mid-grey, then sketch a very basic shape for the face, focusing on the ears, trunk, tusk and eyes. Make sure the ears are much bigger than the head and trunk.

2 Outline your sketch using dark grey paint or marker, adding lines to the trunk.

3 Now start shading the eyes, ears and trunk with a light grey paint.

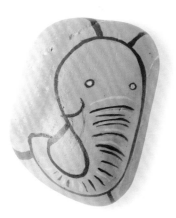

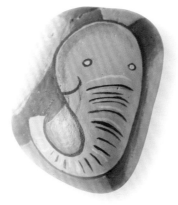

4 Add pink to each of the ears and place a blob on each of the elephant's cheeks.

5 Paint the outer areas of the ears in dark grey, and add a shadow to the top of the head.

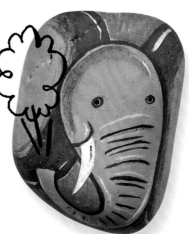

6 Use black pen to fill in the pupils of the eyes. Use white paint to colour the tusk and add lines around the ears. Varnish the pebble once the paint is dry.

FROG FACE

These green and brown amphibians love insects and a little bit of water, and make the perfect pebble pet. Focus on the eyes and decorating the skin with coloured spots – all of which will add charm and character.

YOU WILL NEED

- Round pebble
- Damp cloth
- Chalk
- Paintbrushes
- Thin black pen
- Mid-green, dark green, white, yellow, orange and black craft paint
- Varnish

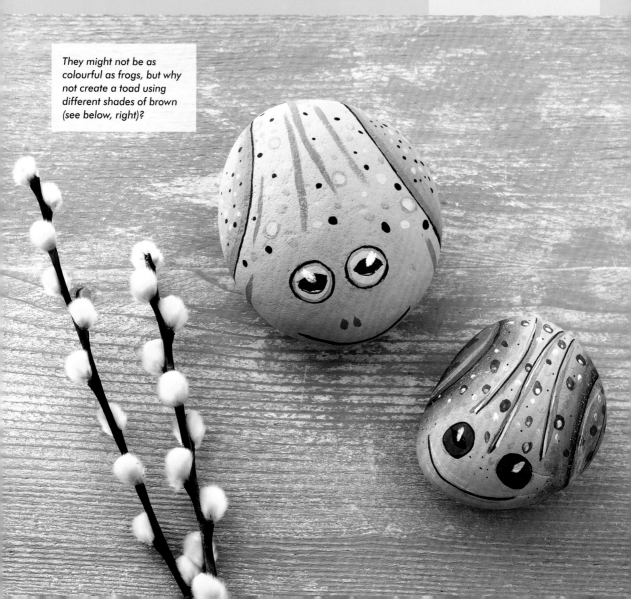

They might not be as colourful as frogs, but why not create a toad using different shades of brown (see below, right)?

1 Pick a round pebble and clean it with a damp cloth.

2 Using chalk, make a basic sketch by drawing two curved lines for the legs on each side and two circles on the front for the eyes.

3 Paint the body and legs with green paint. Add a second layer of paint once the first is dry.

4 Using a darker green, create two or three lines on the frog's back, then outline the legs and add a little bit of shadow on the inside of the outline. Add a line of dark green on either side of the frog's face and two dots for the nose.

5 Add yellow spots all over and colour in the eyes.

6 Outline some of the spots and the eyes with orange paint.

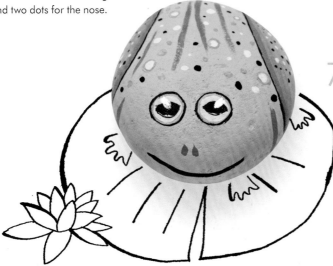

7 With black paint, outline the eyes and add oval-shaped pupils to their centres. Scatter black spots over the body and give your frog a playful grin. Add white to the eyes, then varnish the pebble once the paint is dry.

FARMYARD FRIENDS

There is plenty of inspiration to be found in the farmyard, so take your pick or create a pebble farm of your own from a range of animals that will suit a variety of pebble shapes and sizes.

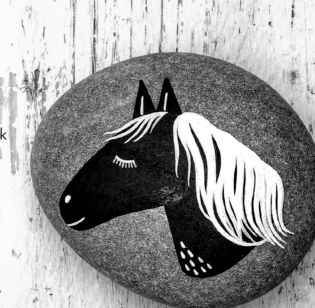

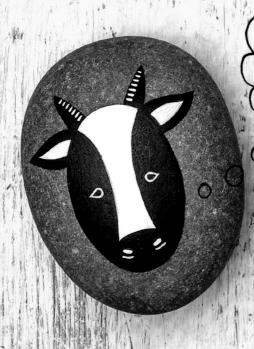

A front view of a goat allows you to include both horns, making it easily recognisable.

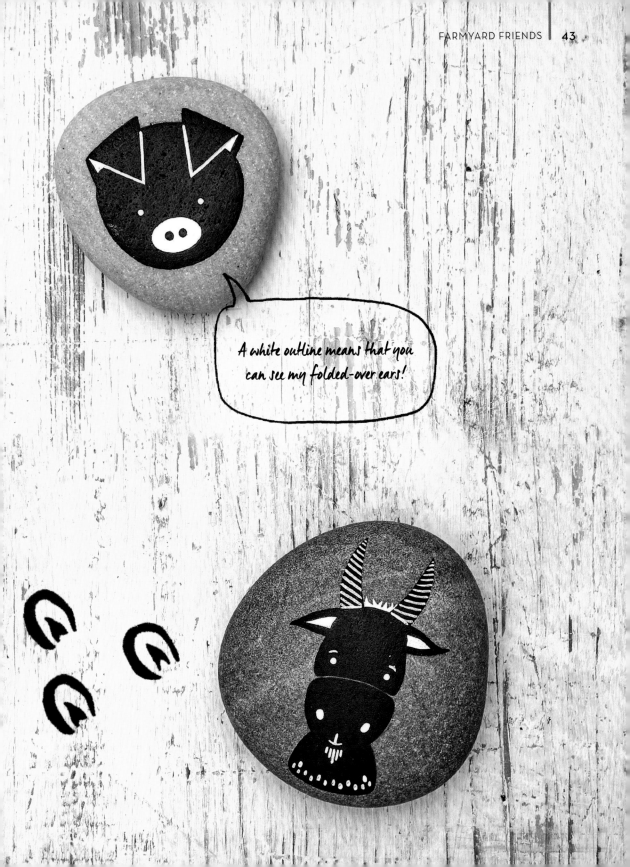

JELLYFISH PEBBLES

These aquatic and gelatinous animals come in so many strange and colourful forms – some are even fluorescent! You are invited to use your unlimited imagination to paint the best jellyfish on your pebble. Use silver, gold or glitter for extra sparkle.

YOU WILL NEED

- Round pebble
- Damp cloth
- Chalk or pencil
- Paintbrushes
- Thin black pen
- Silver or gold markers
- Duck egg blue, blue, red and white craft paint
- Varnish

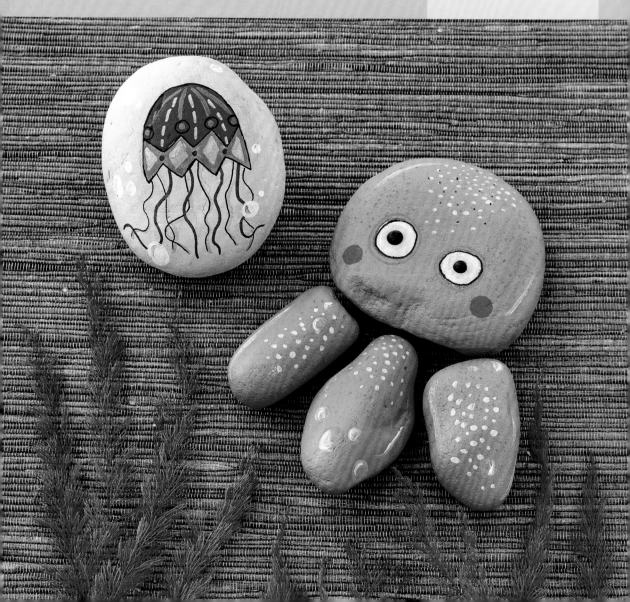

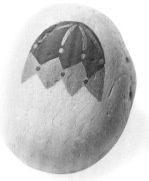

1 Find a round pebble, clean it with a damp cloth, and paint it duck egg blue.

2 Sketch an umbrella shape on the top part of your pebble, with some squiggly-lined tentacles dangling from it.

3 Paint and decorate the umbrella body using red and blue paint.

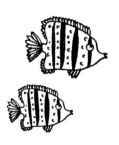

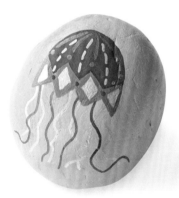

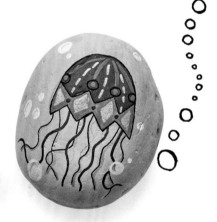

4 Trace the lines of the tentacles with silver or gold pens. Add some more details to the body using the silver pen.

5 Outline elements of the body and the body itself with black pen. To create that 'under the sea' vibe, add bubbles around your jellyfish using white and blue paint. Varnish the pebble once the paint is dry.

Use more than one pebble to create a monster jellyfish that will really impress!

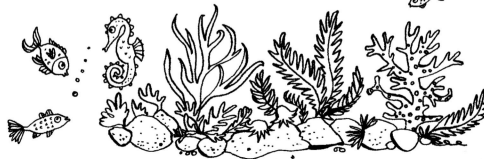

MISCHIEVOUS MONKEY

Monkey around with your pebbles to create a playful primate like this one. Add jungle leaves in the background or even a bunch of bananas.

YOU WILL NEED

- Round, flat pebble
- Damp cloth
- Pencil/chalk
- Paintbrushes
- Thin black pen
- Light brown, mid-brown, dark brown and green craft paint
- Varnish

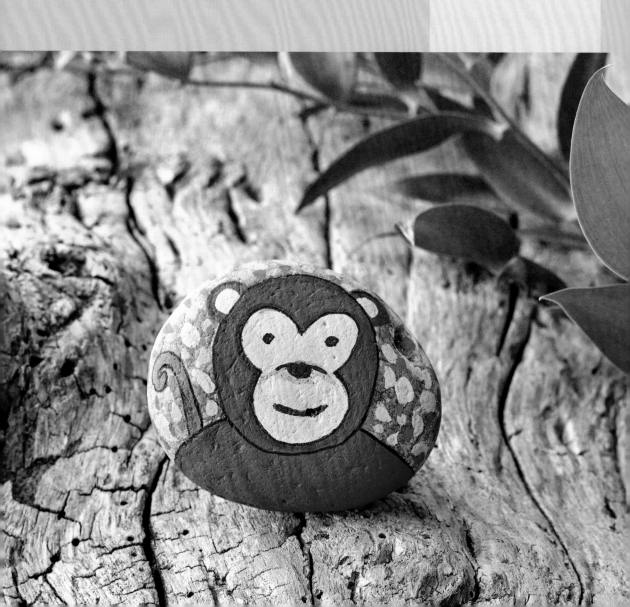

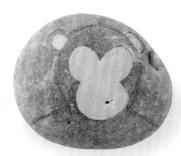

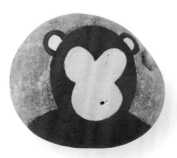

1 Pick a round, flat pebble and clean it with a damp cloth. Use pencil or chalk to sketch the monkey's face onto the stone.

2 Paint the inside of the face and ears using light brown paint.

3 Now paint the rest of the monkey mid-brown.

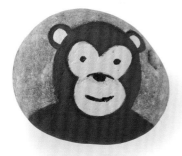

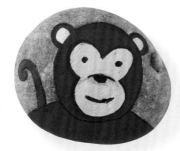

4 Use dark brown to add the eyes, nose and mouth. Outline the inner section of the monkey's face, too.

5 Add a curly tail on one side of the monkey using the mid-brown paint. Outline the outer edges of your monkey and its tail.

6 If you want to make it look as though your monkey is swinging through the trees, add some different-coloured green blobs to the background. Varnish the pebble once dry.

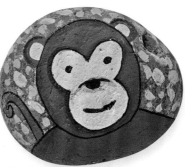

TROPICAL FEATHERS

Get out your brights for an extremely colourful, loud and proud parrot. Try to find a pebble that is wider at the bottom than it is at the top, to mimic the shape of this bird's phenomenal plume of feathers.

YOU WILL NEED

- Flat, triangular pebble
- Damp cloth
- White chalk or pencil
- Paintbrushes
- Thin black pen
- Red, blue, green and white craft paint
- Varnish

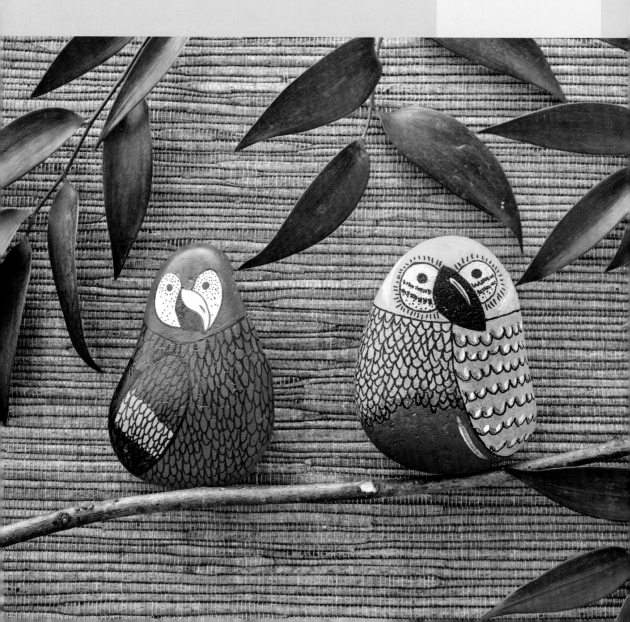

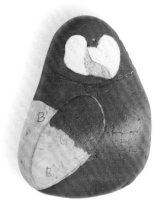

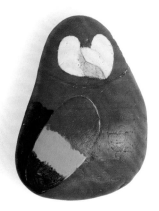

1 Clean your triangular pebble with a damp cloth and sketch out the different parts of your parrot, including the main body, wing, head, eyes and beak. It is useful to lightly mark out the colours you intend to paint.

2 Paint most of the body, wing and head in red. Use white paint to colour in the face and part of the beak.

3 Next, add blue and green to the wing, and blue to the tail.

SQUAWK!

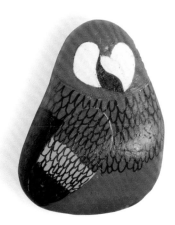

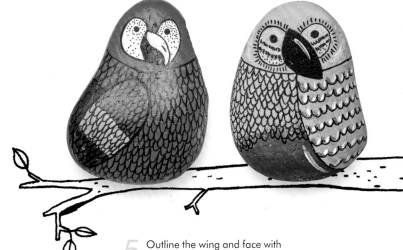

4 Use a fine black pen to colour the other half of the beak, then apply a 'U' pattern to the body, tail and wing.

5 Outline the wing and face with your black marker. Add two dots for the eyes, and, for a lovely finishing flourish, mark small dots on the white part of the face. Varnish the pebble once dry.

FLOCK OF SHEEP

A sheep is one of the easiest animals to paint and you'll only need two colours: black and white! Think of the body as a cloud, adding simple black lines for legs and a little oval face with ears. Vary the features to give each sheep its own character!

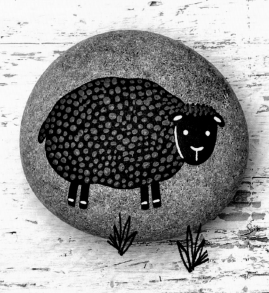

I'm super easy to draw, which means it takes no time at all to create a flock of us!

Add detail, such as a cute, wagging tail, to create character.

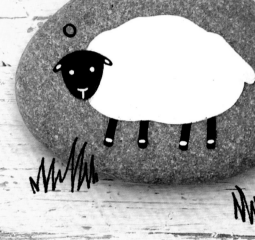

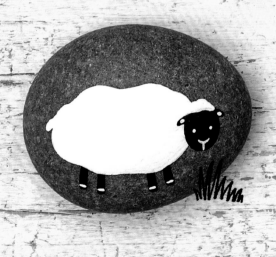

MARCH OF THE PENGUINS

Penguins are fun and social flightless birds who are always dressed well in their tuxedo-style feathers. They are simple to paint and only need white, black and orange to come to life. Little details, such as painting on a fish or fancy winter scarf, add a bit of humour to these cute characters.

YOU WILL NEED

- Oval standing pebble
- Damp cloth
- Chalk
- Paintbrushes
- Thin black pen
- White, orange, blue and black craft paint
- Varnish

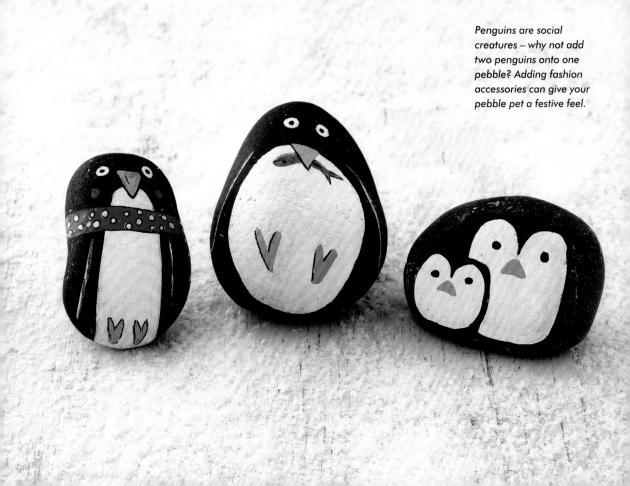

Penguins are social creatures – why not add two penguins onto one pebble? Adding fashion accessories can give your pebble pet a festive feel.

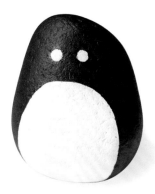

1 Try to find an oval pebble – preferably one that is wider on the bottom. Clean it with a damp cloth and, using chalk, draw a circle for the penguin's breast.

2 Fill in the outline and paint the breast white.

3 Paint the rest of your penguin black and add two white dots for the eyes.

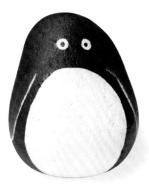

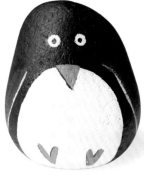

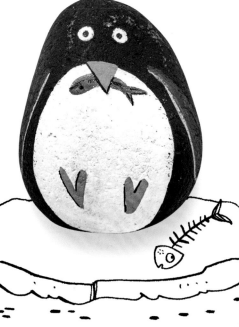

4 Add a white line on each side of the penguin's body to emphasise his small wings. Add black dots to the eyes using black paint or a pen.

5 Draw on some V-shaped feet and a triangle for a beak using orange paint. Add a blue fish to your hungry penguin's mouth. Varnish the pebble once the paint is dry.

SEALED WITH A KISS

I struck lucky and found the perfectly shaped stone for this playful seal pup. If you can only get your hands on a round rock, focus on the seal's face (see below).

YOU WILL NEED

- Long, narrow pebble
- Damp cloth
- Chalk
- Paintbrushes
- Thin black pen
- Light grey, dark grey and white craft paint
- Varnish

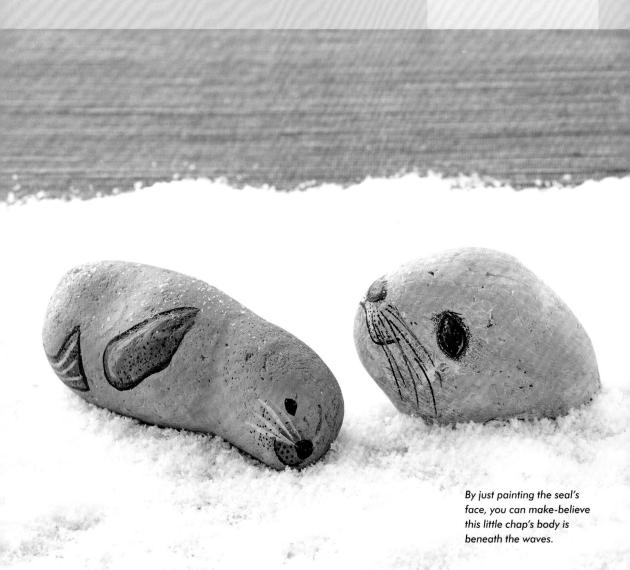

By just painting the seal's face, you can make-believe this little chap's body is beneath the waves.

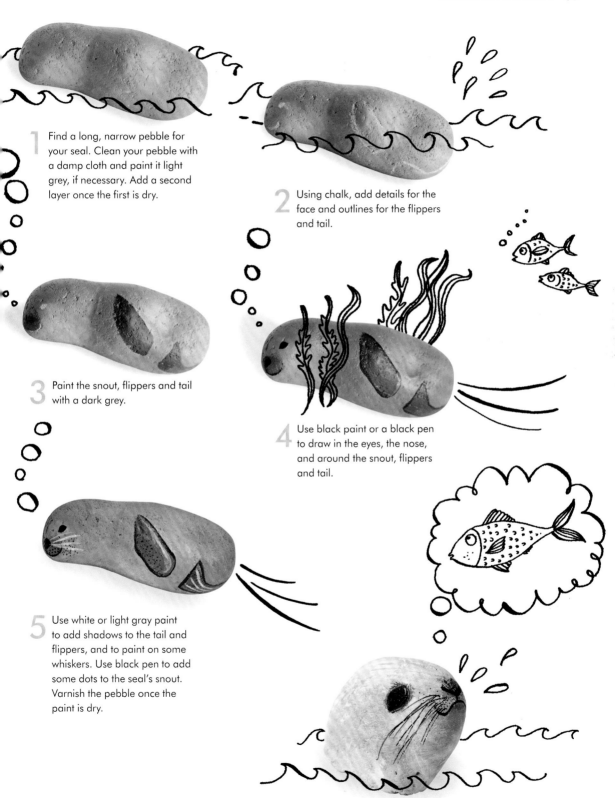

1 Find a long, narrow pebble for your seal. Clean your pebble with a damp cloth and paint it light grey, if necessary. Add a second layer once the first is dry.

2 Using chalk, add details for the face and outlines for the flippers and tail.

3 Paint the snout, flippers and tail with a dark grey.

4 Use black paint or a black pen to draw in the eyes, the nose, and around the snout, flippers and tail.

5 Use white or light gray paint to add shadows to the tail and flippers, and to paint on some whiskers. Use black pen to add some dots to the seal's snout. Varnish the pebble once the paint is dry.

TAKE IT SLOW

Take your time creating this sluggish snail pet pebble. Follow these steps if you want to create a snail with a brown shell, or look to the red, blue and orange variation for some more colour and inspiration.

YOU WILL NEED

- Oval standing pebble
- Damp cloth
- White chalk
- Paintbrushes
- Thin black pen
- Dark brown, tan brown, light brown, white, yellow and red craft paint. Red, blue and orange craft paint for variation.
- Varnish

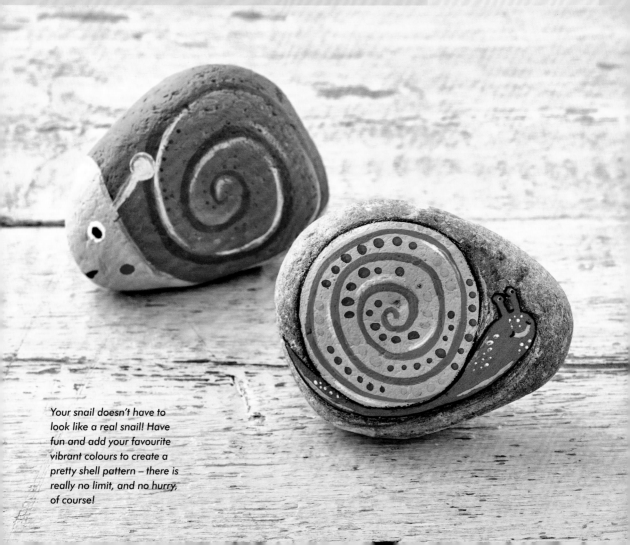

Your snail doesn't have to look like a real snail! Have fun and add your favourite vibrant colours to create a pretty shell pattern – there is really no limit, and no hurry, of course!

1 Find an oval pebble that can stand on its side. Clean using a damp cloth, then decide which end will be the shell and which will be the snail. Paint the shell tan brown and the snail a lighter brown.

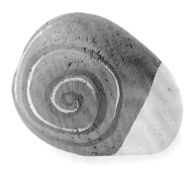

2 Use a dark shade of brown to make the spiral pattern on the shell, then add lighter shadows in white paint.

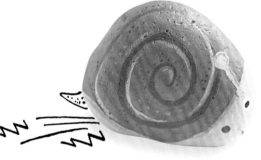

3 I have added yellow and brown dots to my snail's shell, but you can decorate yours any way you wish. Paint a tentacle on the head using the same light brown you used for the snail's face. Add an eye and a big smile. Place a red dot on the face for a rosy cheek.

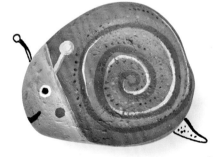

4 Once the paint is dry, turn the pebble over and repeat Steps 2 and 3. Varnish the pebble once the paint is dry.

TAKE FLIGHT

Normally airborne and out of reach, these creatures can be happily tethered to a painted rock to make an attractive pebble pet.

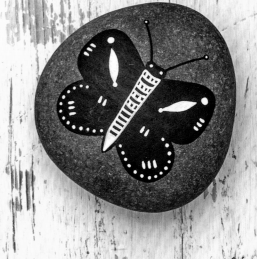

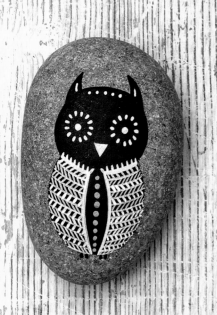

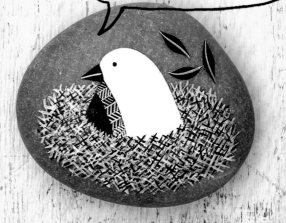

Give me a home and picture me in my nest, complete with textured twig detail.

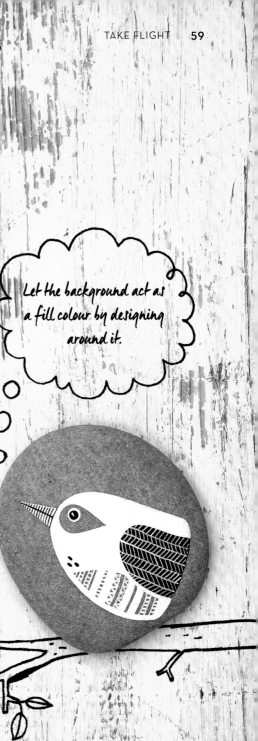

Let the background act as a fill colour by designing around it.

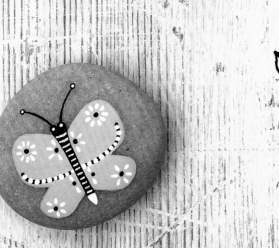

SLIPPERY SNAKE

Play with the patterns on this snake's skin — try different shapes, such as circles, zigzags and squares, to give your cool reptile character.

YOU WILL NEED

- Roundish pebble
- Damp cloth
- Chalk or pencil
- Paintbrushes
- Thin black pen
- Orange, light green, dark green and red craft paint
- Varnish

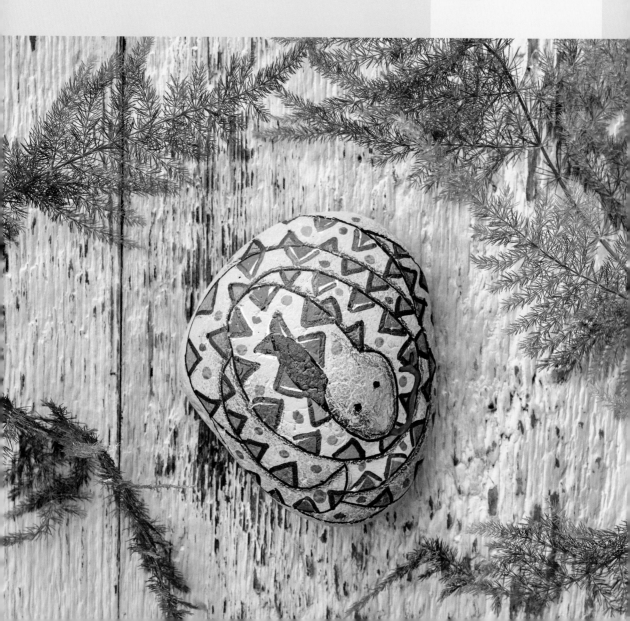

1 Find a roundish pebble and clean it with a damp cloth.

2 Paint your pebble light green.

3 Sketch out the long, curly body of your snake and add the head near the centre of your pebble.

4 Add triangular shapes to decorate the skin. Fill in the patterns with orange and dark green paint.

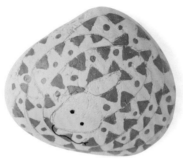

5 Dot the same orange and dark green on the body, and create the eyes and long tongue with a thin black pen.

6 Outline your snake and fill in any gaps using a thin black pen. For extra impact, go over the tongue line in red paint. To add texture and depth, use pencil shading around the face and edges of the curved body. Varnish your pebble to secure the paint and pencil shadings.

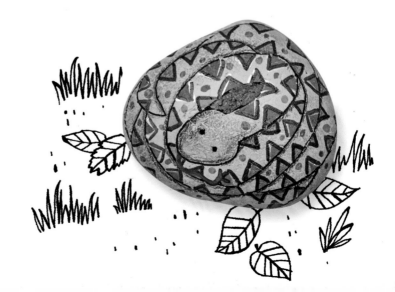

EARN YOUR STRIPES

Choose an elongated pebble to match the shape of the zebra's face. This design is very simple and you can create the cutest zebra using just a tricolour of black, white and pink.

YOU WILL NEED

- Elongated pebble
- Damp cloth
- Chalk or pencil
- Paintbrushes
- Thin black pen
- White, light pink, dark pink and black craft paint
- Varnish

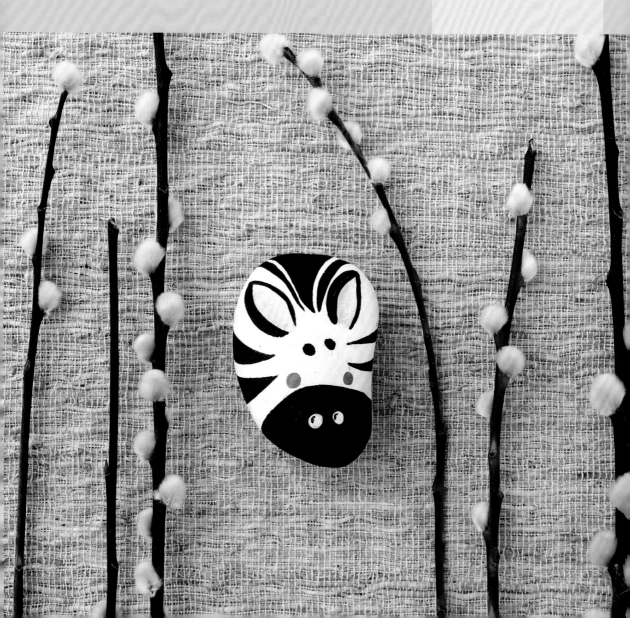

1 Choose an elongated pebble and clean it with a damp cloth. When dry, add two layers of white paint, applying the second layer once the first is dry.

2 With a pencil, sketch the stripes, nose, nostrils and pointed ears onto the pebble.

3 Use black to paint around the nostrils.

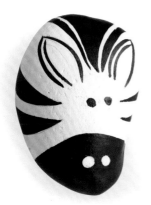

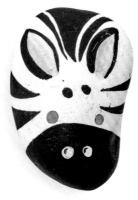

4 Fill in the stripes, eyes and outline of the ears. You can use black pen to help you with the finer lines.

5 Use light pink to fill in the inner ears and dark pink to add a circle on each side of the face, for rosy cheeks. Varnish the pebble once the paint is dry.

CUTE KITTIES

Always curled up in the cosiest of corners, cats make the cutest of pets. Why not work with the pebble's natural pattern to create this creature's mottled fur?

YOU WILL NEED

- Flat, oval pebble
- Damp cloth
- Paint palette
- Sponge
- Chalk
- Paintbrushes
- Brown, white and black craft paint
- Varnish

This kitty (below) is in a playful mood – use a roundish standing pebble to create your own cheeky cat!

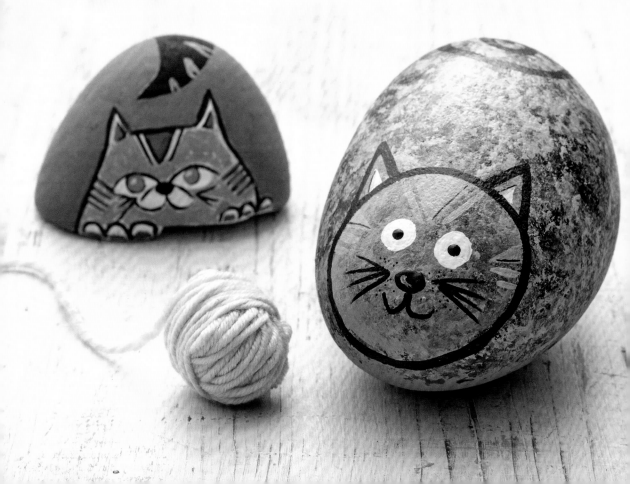

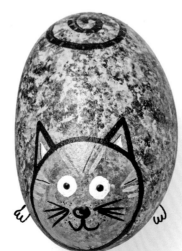
Apply two layers of brown paint.

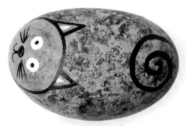

1 Find a flat, oval pebble and clean it with a damp cloth.

3 Prepare brown, black and white paint on a palette and mix together. Dip a sponge into the mixture and dab it onto the pebble to cover it.

Outline the face and tail with black paint.

4 Once the paint is dry and you are happy with your textured fur, use chalk to sketch a round head with two pointed ears on one end of the pebble and a curly tail on the other end.

5 Outline the face and tail with black paint.

6 Focusing on the face, add a pair of eyes and fill in the inner ears using white paint. Use black paint to add the nose, mouth and whiskers. Apply a black dot to each eye.

7 Use light shades of brown to paint details on the face and tail. Varnish once the paint is dry.

MEOW!

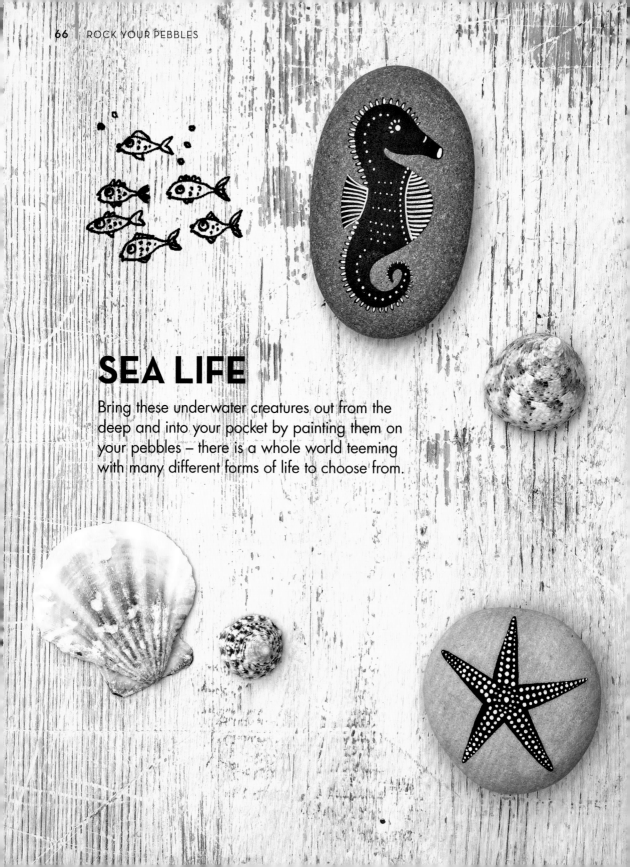

SEA LIFE

Bring these underwater creatures out from the deep and into your pocket by painting them on your pebbles – there is a whole world teeming with many different forms of life to choose from.

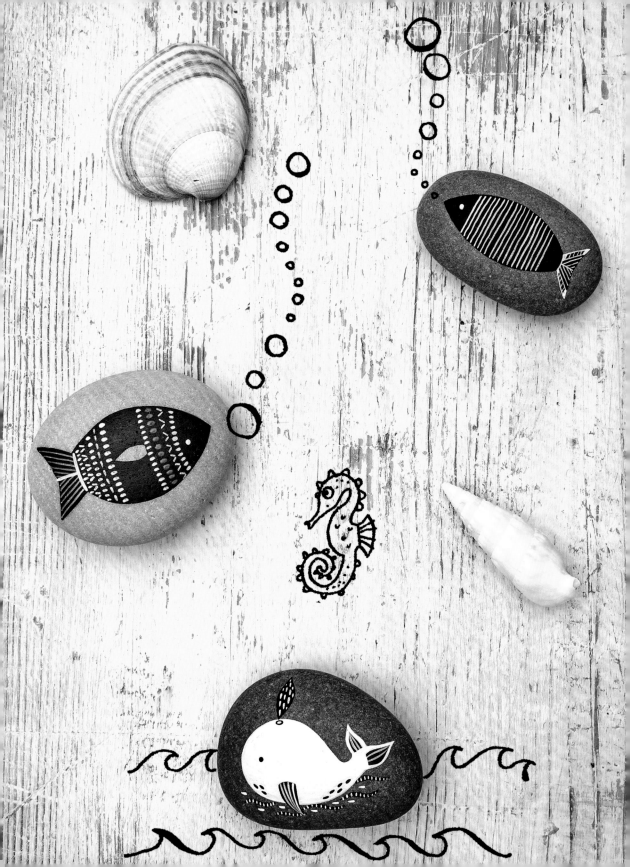

A DOG'S LIFE

As man's best friend, dogs definitely deserve a top place in your pebble pet collection. Follow the steps opposite to create the dog's face, or go full whack and include the body, too; just choose a slightly bigger pebble.

YOU WILL NEED

- Roundish, standing pebble
- Damp cloth
- Chalk
- Paintbrushes
- White and black markers
- Thin black pen
- Mid-brown, beige and dark brown craft paint
- Varnish

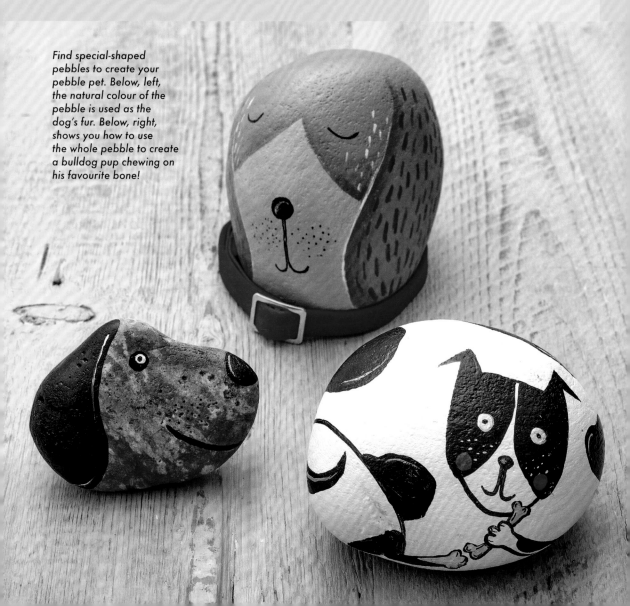

Find special-shaped pebbles to create your pebble pet. Below, left, the natural colour of the pebble is used as the dog's fur. Below, right, shows you how to use the whole pebble to create a bulldog pup chewing on his favourite bone!

1 Find a roundish, standing pebble and clean it with a damp cloth.

2 Apply two layers of mid-brown paint and, once dry, sketch the lower part of the face, including the floppy ears, with chalk. Mark out the eyes and nose, too.

3 Use beige paint to colour the muzzle.

4 Outline the muzzle and ears using a dark brown paint, to create shadow and depth.

5 Use black pen to add eyes, a nose and a mouth.

6 Add thin, brown, dashed lines over the floppy ears and some white dashes between the eyes and ears. Dot a black marker around the mouth. Add a layer of varnish once the paint is dry.

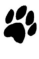
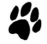
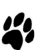
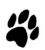

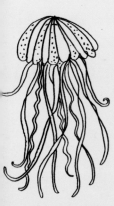

UNDER THE SEA

Experiment with patterns and colours to create a sizable shoal of fantastic fish. Paint fat, slim or round fish – your pebble is your oyster or canvas!

YOU WILL NEED

- Large, oval pebble
- Damp cloth
- Chalk
- Paintbrushes
- Thin black marker
- Navy, blue, orange, red and white craft paint
- Varnish

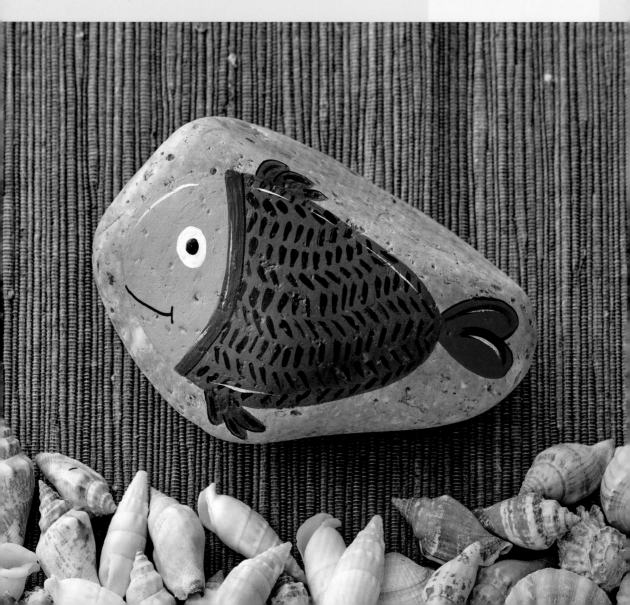

1 Find a large, oval pebble and clean it with a damp cloth.

2 Use chalk to sketch your fish outline.

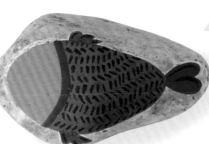

3 Paint the head orange and the body blue.

4 Use red paint to divide the head and body, then fill in the tail.

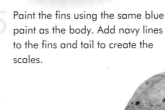

5 Paint the fins using the same blue paint as the body. Add navy lines to the fins and tail to create the scales.

6 Add shadows using white paint and black marker, then add the eye and mouth to the face. Varnish the pebble when dry.

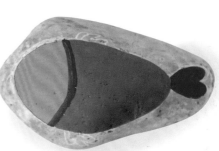

KANGAROO AND HER JOEY

This 'roo has bounced all the way from Australia straight into your pocket. Design just one, or create a joey to keep her company.

YOU WILL NEED

- Large, flat, round pebble
- Damp cloth
- Chalk
- Paintbrushes
- Thin black marker
- Light brown, mid-brown and dark brown craft paint
- Varnish

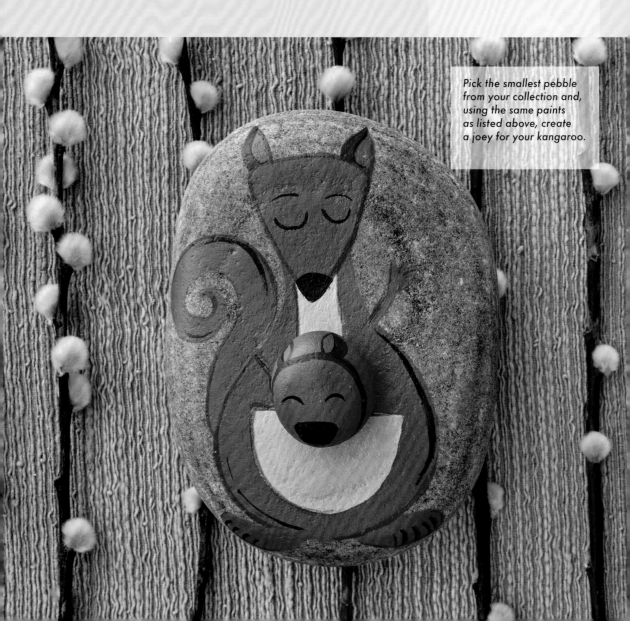

Pick the smallest pebble from your collection and, using the same paints as listed above, create a joey for your kangaroo.

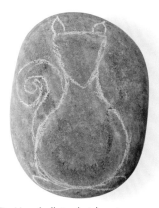

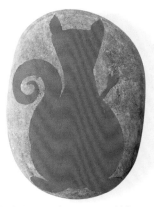

1 Find a large, flat, round pebble and clean it with a damp cloth.

2 Use chalk to sketch out your kangaroo.

3 Paint your kangaroo mid-brown. Add a second layer of paint when the first one is dry.

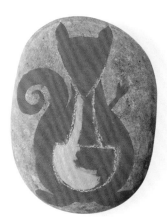

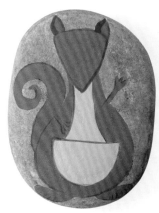

4 Use chalk to sketch out the kangaroo's belly, and paint it light brown.

5 Outline the kangaroo using a thin paintbrush and dark brown paint.

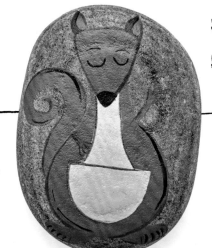

6 Add details to the face and shadows to the body and tail with black marker. Varnish the pebble when completely dry.

CLIMBING KOALA

You will find these grey marsupials climbing trees and munching on leaves. Why not add a baby koala to your pet's back to create a super-cute companion?

YOU WILL NEED

- Flat, round pebble
- Damp cloth
- Chalk
- Paintbrushes
- Thin black marker
- Light grey, dark grey, brown, white, green and red craft paint
- Varnish

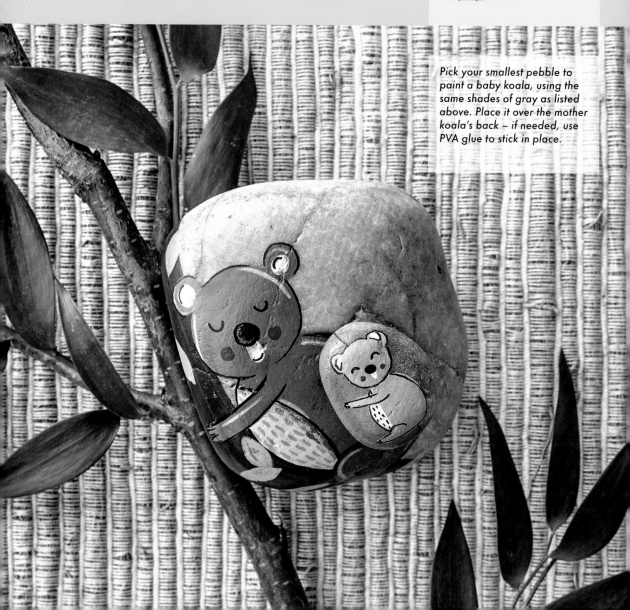

Pick your smallest pebble to paint a baby koala, using the same shades of gray as listed above. Place it over the mother koala's back – if needed, use PVA glue to stick in place.

1 Find a flat, round pebble and clean it with a damp cloth. Use chalk to outline the basic shape of the koala climbing up the trunk of a tree.

3 Now paint the whole body dark grey.

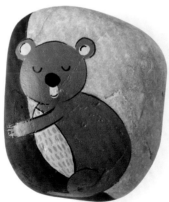

2 Paint the trunk brown and, once the paint is dry, draw the arm, leg and ears.

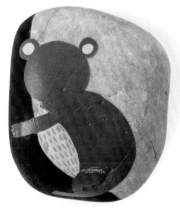

4 Use white to paint the tummy and inner ears. Add light grey dashed lines over the tummy to add texture.

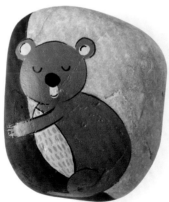

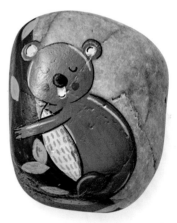

6 Add shading with white paint and black marker, and finish off your koala with two rosy red cheeks. Paint leaves on the trunk to give your koala something to nibble on. Varnish the pebble once the paint is dry.

5 Use the black marker to outline your koala. Add the nose and eyes, and paint the mouth area white.

DUCKS FOR LUCK

Generally found bobbing along on the top of a peaceful pond or lake, ducks offer a range of feather patterns for the pebble artist – or just make up your own!

Adding well-placed lines around the bill and neck will help to delineate those areas.

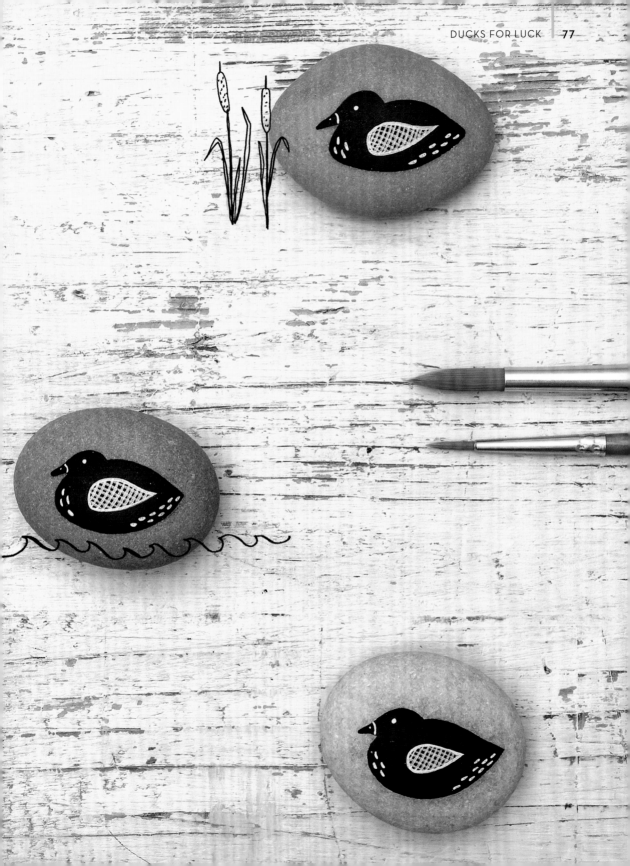

LEAPING LEMUR

Distinguished by their stripy tail and bright yellow eyes, lemurs love to leap from tree to tree. Why not create a conspiracy of lemurs in different colours?

YOU WILL NEED

- Large, standing pebble
- Damp cloth
- Chalk
- Paintbrushes
- Silver marker
- Thin black marker
- Light grey, dark grey, green, black and yellow craft paint
- Varnish

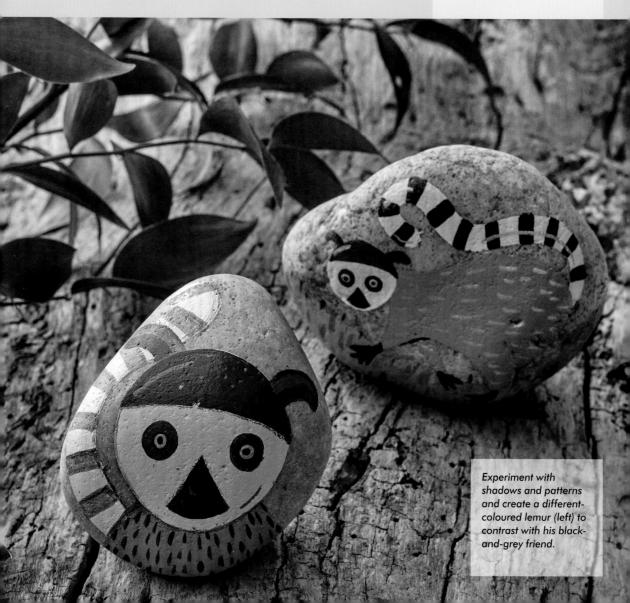

Experiment with shadows and patterns and create a different-coloured lemur (left) to contrast with his black-and-grey friend.

1 Find a large, standing pebble and clean it with a damp cloth. Sketch the basic shape of your lemur, along with a line for it to balance or walk on.

2 Paint the body dark grey and the head and tail in a lighter grey.

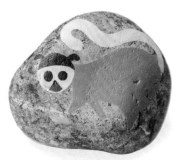

3 Use black to paint the top part of the head, ears, eyes and triangular nose.

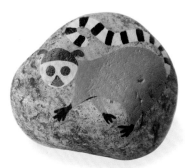

4 Paint the lemur's feet black, then paint black stripes all over its long tail.

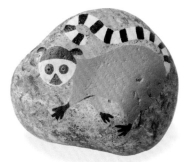

5 Paint two small yellow circles on the eyes. When the yellow paint is dry, make a dot in each eye with a thin black marker.

6 Using the silver marker, create shading over the head and tail, then add short, horizontal lines all over the body. Create grass for the lemur to walk on using different shades of green paint. Apply varnish once the paint is dry.

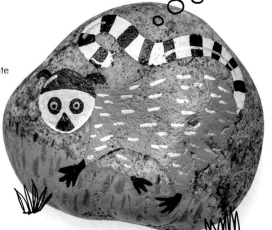

THE LION'S DEN

Lions come from the *Panthera* family, renowned for strong and ferocious features. This project transforms those features into cute and friendly ones, making this lion the ideal pet pebble.

YOU WILL NEED

- Flat, round pebble
- Damp cloth
- Chalk
- Paintbrushes
- Mustard yellow, light yellow, dark brown, mid-brown, black and white craft paint
- Varnish

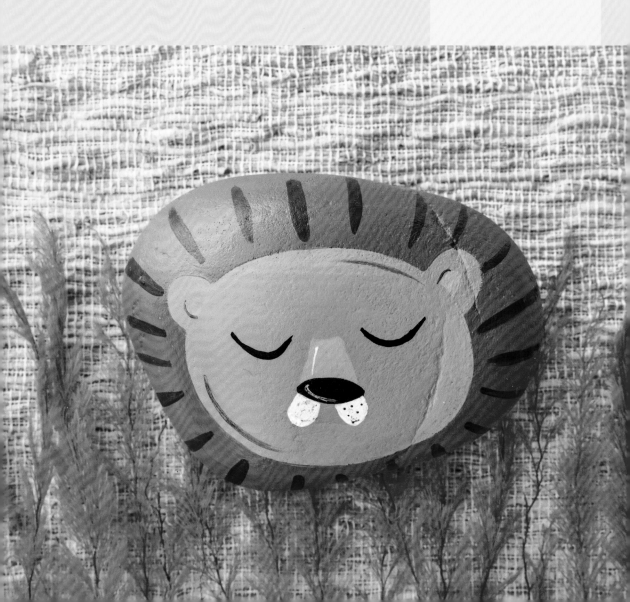

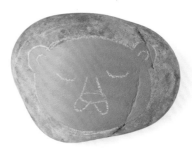

1 Find a flat, round pebble and clean it with a damp cloth. Draw an oval shape with chalk and add two small ears on top.

2 Paint the inside of your sketch mustard yellow. When the paint is dry, sketch the eyes and nose.

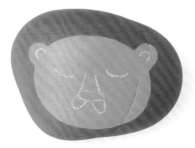

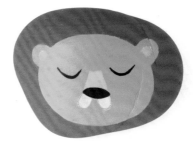

3 Paint the remaining part of the pebble – the mane – mid-brown.

4 Use light yellow paint for the nose and inner ears, and black for the eyes and nose. Add white paint below the nose to create the mouth.

Z Z Z z z z

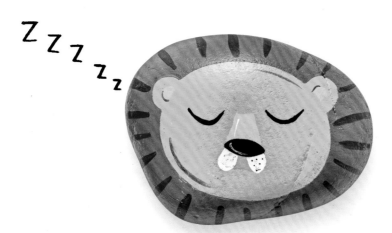

5 Add shadows using white and brown paint on the face. Lastly, add dark brown lines over the lion's mane. Varnish the pebble once the paint is dry.

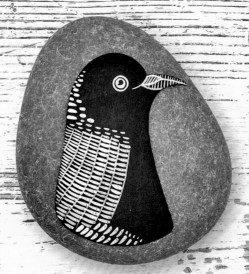

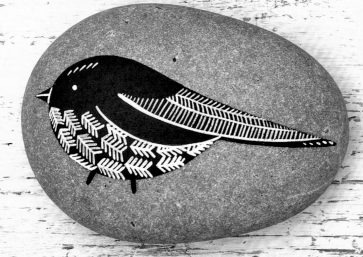

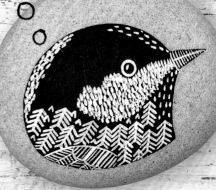

Add pattern, texture and depth with white-pen detailing.

GARDEN BIRDS

Go for maximum impact with black-and-white designs of your favourite feathered friends. Earthy-coloured pebbles will ground your designs in nature and allow the birds to punch out from the background.

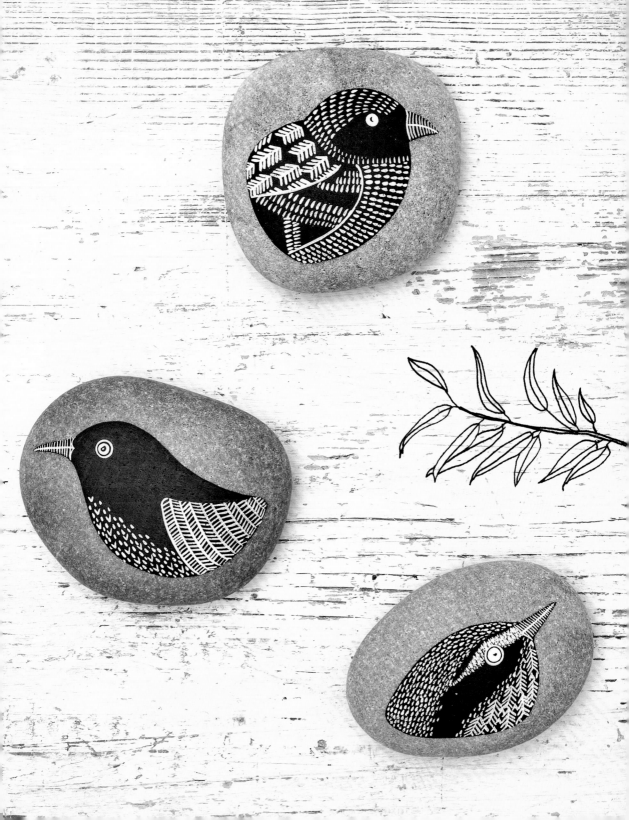

AWESOME ALPACA

It's time for the fluffiest pet pebble you have ever seen! All the way from the Peruvian wilderness – it's the awesome alpaca. Get creative by adding a little habitat for your pet. Follow the steps opposite to find out more.

YOU WILL NEED

- Flat, round pebble
- Damp cloth
- Chalk
- Paintbrushes
- Black pen or marker
- Pencil
- White, light brown and green craft paint
- Varnish

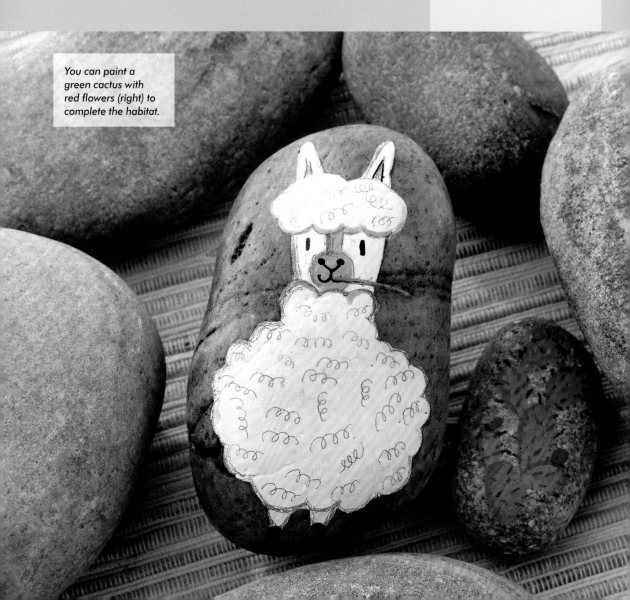

You can paint a green cactus with red flowers (right) to complete the habitat.

1 Find a flat, round pebble and clean it with a damp cloth.

2 Use chalk to outline the basic shape of the alpaca.

3 Emphasise a round, fluffy body, and then paint the inside of the outline with white paint.

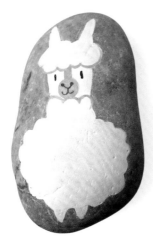

4 Paint the middle of the face light brown and use the same colour to outline the face. Use a thin black pen to add the eyes, nose and mouth.

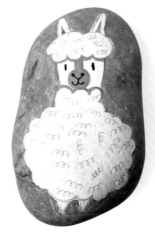

5 With a sharp pencil, add swirls around the alpaca's fluffy body. Sketch in the inner ears and add additional shadows if you wish.

6 Use the black pen or paint to add two little feet. Paint a fine green line next to the alpaca's mouth so he doesn't go hungry. Once the paint is dry, add a layer of varnish.

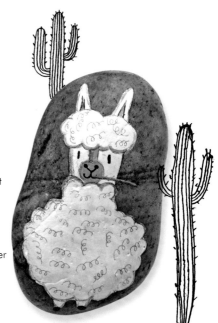

THE BIG CHEESE

They hide in walls and under floorboards, and steal our cheese, but mice still make the cutest pet pebbles! Remember to give your mouse a lump of cheese to gnaw on.

YOU WILL NEED

- Semi-circular, standing pebble
- Damp cloth
- Pencil and chalk
- Paintbrushes
- Thin black pen
- Light grey, pink, white, yellow and black craft paint
- Varnish

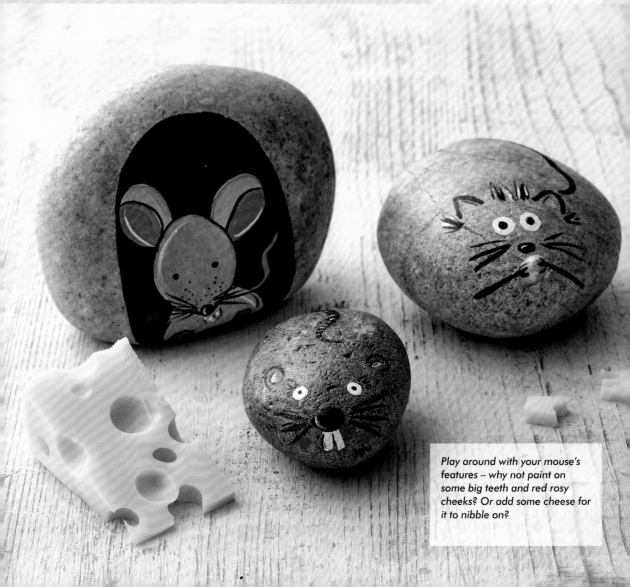

Play around with your mouse's features – why not paint on some big teeth and red rosy cheeks? Or add some cheese for it to nibble on?

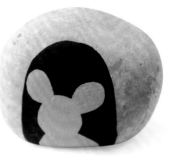

1 Find a semi-circular, standing pebble and clean it with a damp cloth. Sketch a semi-circle in the centre of your pebble.

2 Paint the semi-circle black and, once dry, use chalk to create the outline of your mouse.

3 Paint the mouse's body, head and ears in light grey.

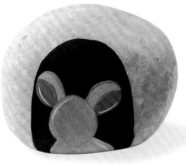

4 Use pink for the inner ears and apply thin white and grey lines around the ears, face and body, to create shadows and depth.

5 Outline the mouse using black pen, and add fine lines and dots to each side of the face to create whiskers. Use yellow paint to add a piece of cheese for your mouse to nibble on. Finally, add a pink tail and, when dry, varnish the pebble.

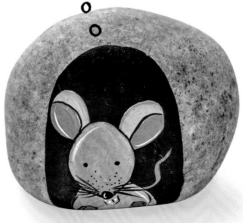

THE ORIGINAL GANGSTER OTTER

This otter couldn't be any more chilled out. Paint him floating on his back along the river, just cruisin' and watching the world go by.

YOU WILL NEED

- Flat, elongated pebble
- Damp cloth
- Chalk
- Paintbrushes
- Thin black and white markers
- Blue, red, white, black and light grey craft paint
- Varnish

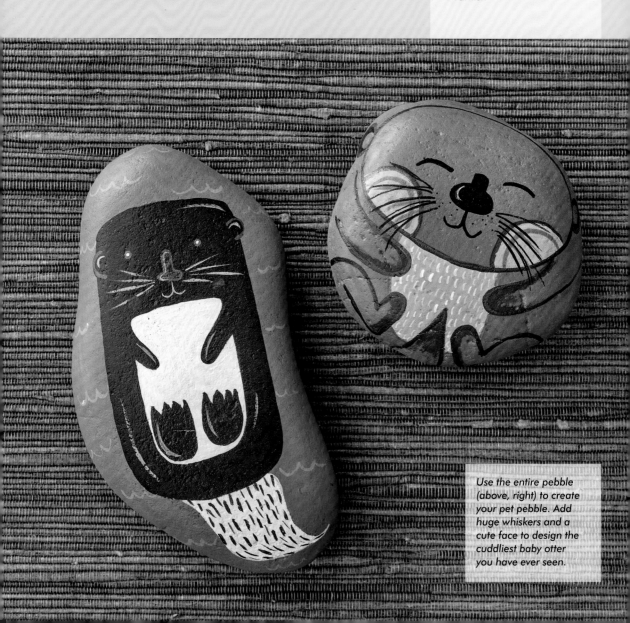

Use the entire pebble (above, right) to create your pet pebble. Add huge whiskers and a cute face to design the cuddliest baby otter you have ever seen.

1 Find a flat, elongated pebble and clean it with a damp cloth.

2 Use chalk to sketch the basic shape of your otter, his arms, legs, belly and face. Paint the area around your otter blue.

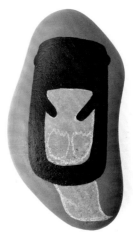

3 Paint everything but his belly, feet and tail black.

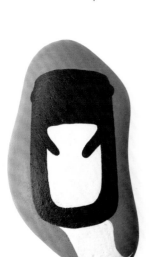

4 Use white paint to fill in his belly and tail.

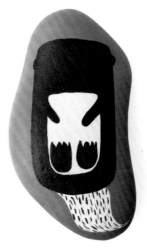

5 Use flecks of black to decorate the tail and paint the feet.

6 Add details to the face using light grey paint, white marker and red paint. Add some white shadows to the body to create depth, and add white swirls over the blue water. Apply varnish to the pebble once the paint is dry.

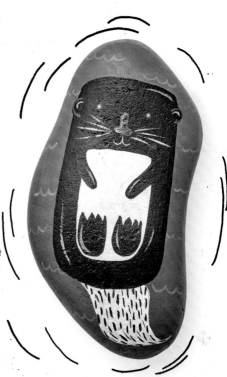

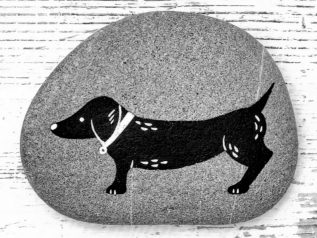

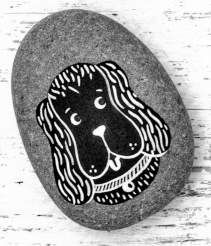

BREEDS OF DOG

Whether it's a pooch or a pedigree, let the shape of your stone lead the way in deciding if you want to paint a whole dog or just its characterful face.

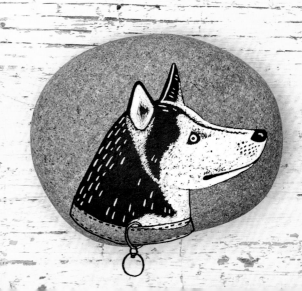

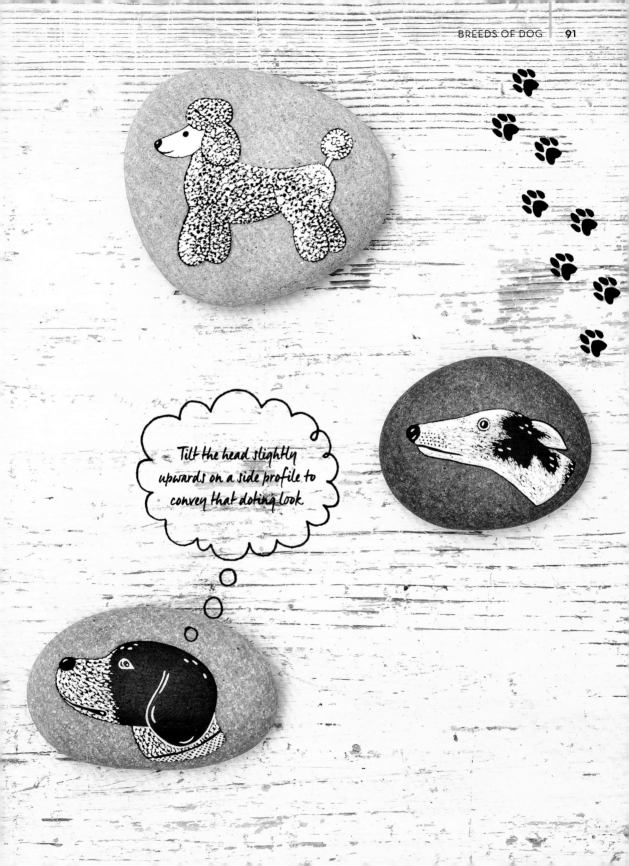

BEAR HUG

Paint the largest land carnivore on a pebble small enough to fit in your pocket. You can keep each other warm!

YOU WILL NEED

- Flat, round pebble
- Damp cloth
- Pencil or chalk
- Paintbrushes
- Thin black pen
- White, beige and red craft paint
- Varnish

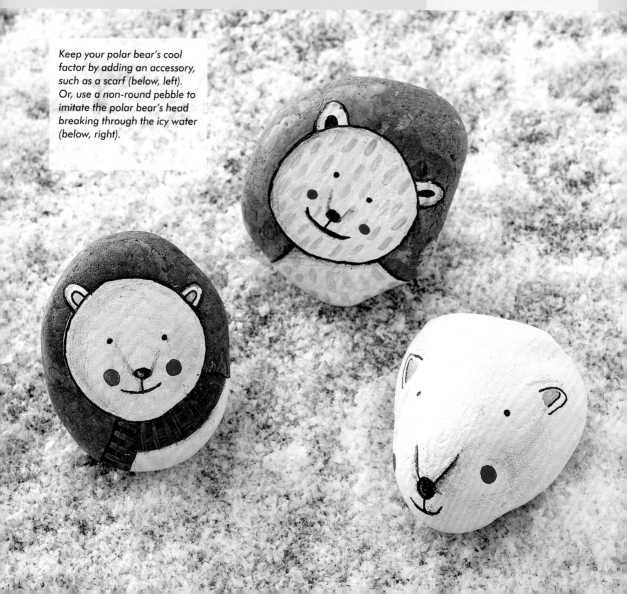

Keep your polar bear's cool factor by adding an accessory, such as a scarf (below, left). Or, use a non-round pebble to imitate the polar bear's head breaking through the icy water (below, right).

1 Find a flat, round pebble and clean it with a damp cloth.

2 Use a pencil to sketch the head, body and ears. If the pencil is hard to see, use chalk.

3 Fill in the outlines and paint the polar bear white.

4 Use a black pen to outline the head, body and ears – then add eyes, a nose and a mouth.

5 Paint beige dashes on your polar bear, creating the fluffy texture of his fur. Use the pencil to define the shape of his snout.

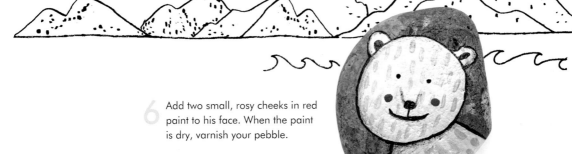

6 Add two small, rosy cheeks in red paint to his face. When the paint is dry, varnish your pebble.

BUNNY HOP

You will only need grey, white and pink paint to complete this simple yet ravishing rabbit. The secret to this design is a big, fluffy tail at the back of your pebble.

YOU WILL NEED

- Flat, round pebble
- Damp cloth
- Chalk
- Paintbrushes
- Silver marker
- Black pen or marker
- Light grey, dark grey, white and pink craft paint
- Varnish

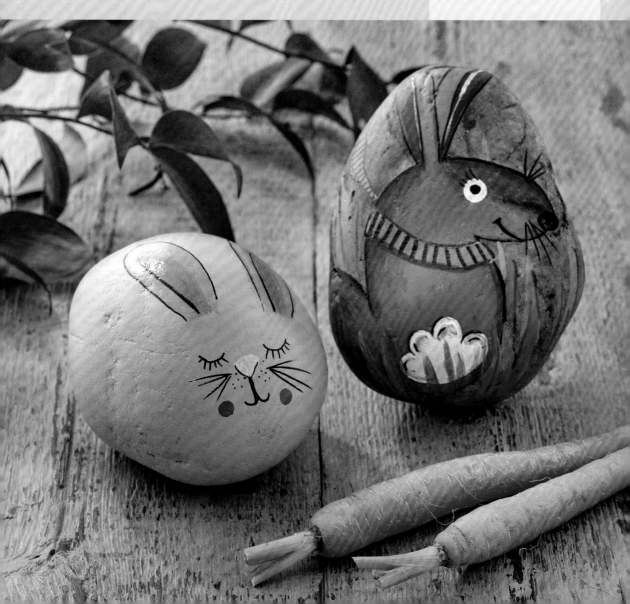

1 Find a flat, round pebble and clean it with a damp cloth. Apply two layers of light grey paint.

2 Use chalk to sketch two large ears, a nose and a mouth.

3 Paint the inside of both ears dark grey.

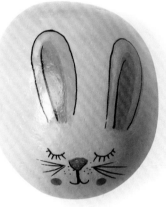

6 On the other end of the pebble, add a fluffy tail using grey and white paint. Outline the tail with black marker. Varnish the pebble once dry.

4 Add details to the face using the black pen or marker. Fill in the nose with your silver marker.

5 Add pink to the inner ears and paint a small dot on each side of the face. Outline the ears and one side of each inner ear with black pen.

Create some long grass (opposite, right) for your rabbit to hop around in.

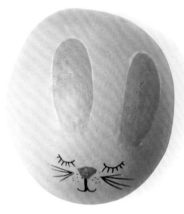

LAZY DAYS

Create this slow-moving mammal by following the steps opposite. Add leaves and branches to make your sloth feel at home and even more chilled out than usual.

YOU WILL NEED

- Flat, round pebble
- Damp cloth
- White chalk
- Paintbrushes
- Thin black pen
- Dark brown, light brown, beige and green craft paint
- Varnish

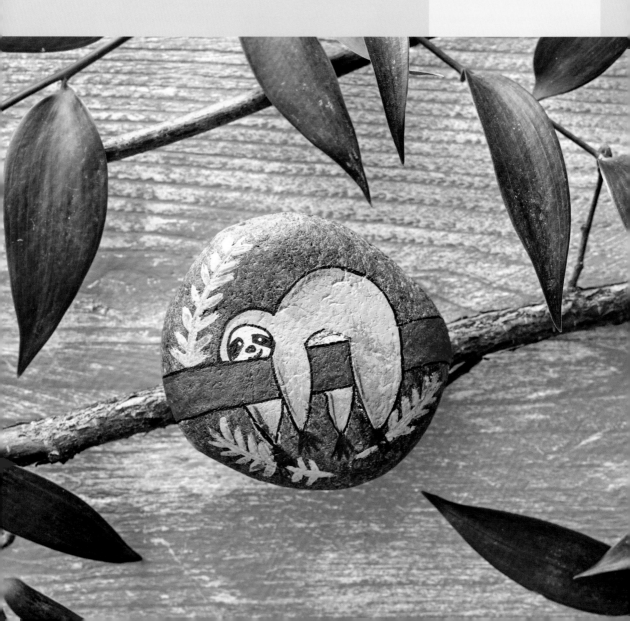

1 Find a flat, round pebble and clean it with a damp cloth.

2 Using chalk, sketch two horizontal lines across the centre of the pebble. Draw two semi-circles, one smaller than the other, on the top line.

3 Sketch the sloth's hanging arms and legs and use dark brown paint to colour between the horizontal lines, creating a branch for your sloth to flake out on.

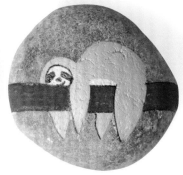

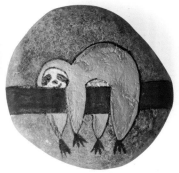

4 Paint the body, arms and legs light brown and use beige to highlight the face and belly.

5 Outline the arms and legs with a thin black pen and draw the face.

6 Use dark brown to paint the claws on the ends of each of the arms and legs. Outline the rest of the sloth using a black pen.

7 Add some green leaves and then, when the paint is dry, varnish your pebble.

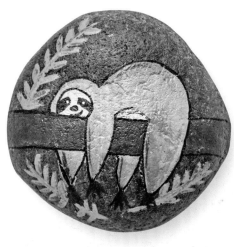

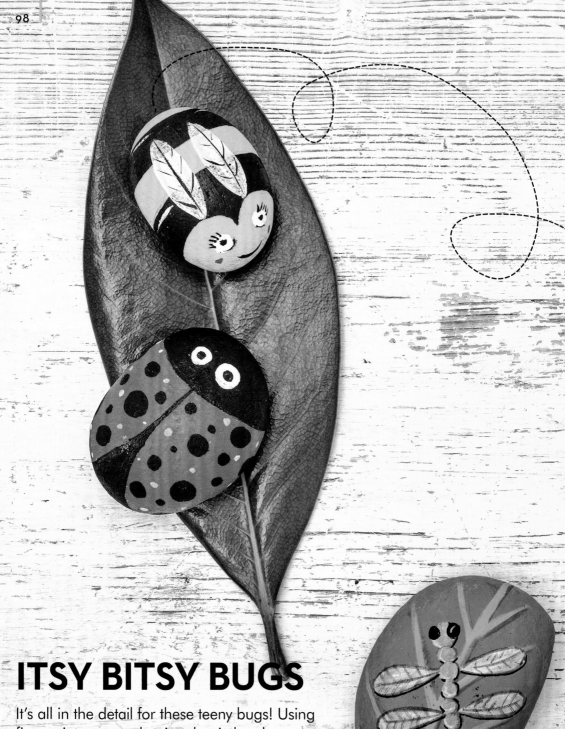

ITSY BITSY BUGS

It's all in the detail for these teeny bugs! Using fine-point pens and pointed paintbrushes, you can add some bright and eye-catching patterns, making up your own if preferred.

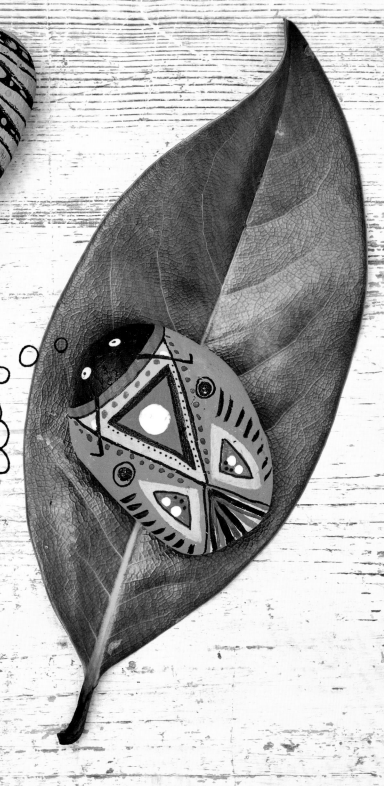

Geometric patterns are particularly striking when outlined in contrasting colours.

SLOW AND STEADY WINS THE RACE

Once you have painted the basic tortoise design, unlock your creativity and experiment with various patterns and colours to create the shell.

YOU WILL NEED

- Flat, round pebble
- Damp cloth
- Chalk
- Paintbrushes
- Black 3D liner
- Green, dark green, brown, dark brown and beige craft paint
- Varnish

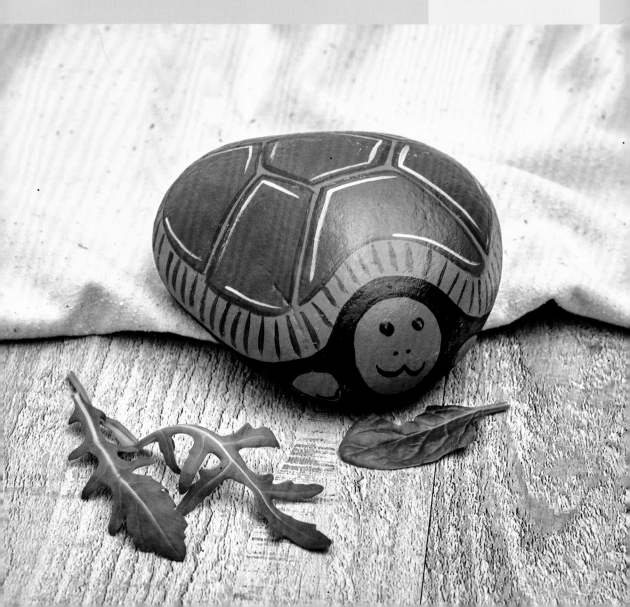

1 Find a flat, round pebble, clean it with a damp cloth, and paint it green. Add a second layer of paint if needed.

2 Outline the shell, head and legs with white chalk.

3 Paint the area around the head and legs dark brown.

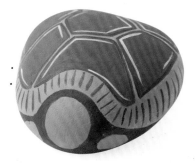

4 Sketch seven hexagons on top of the shell, leaving a border between the hexagons and the edge of the shell. Paint the hexagons brown.

5 Decorate the border with thin, dark green lines and outline the hexagons. Use beige paint to add some lines to the inside of the hexagons.

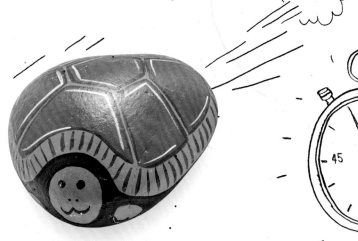

6 Outline the head and arms and add details to the face using a 3D liner. Varnish the pebble when dry.

WOLF AND FOX

This wolf has strayed from the pack and found a cosy home in your pocket. The sleepy fox may want to join him, so consider making him afterwards.

YOU WILL NEED

- Flat, round pebble
- Damp cloth
- Chalk
- Paintbrushes
- White marker
- Thin black marker
- Light grey, mid-grey, dark grey, white and red craft paint
- Varnish

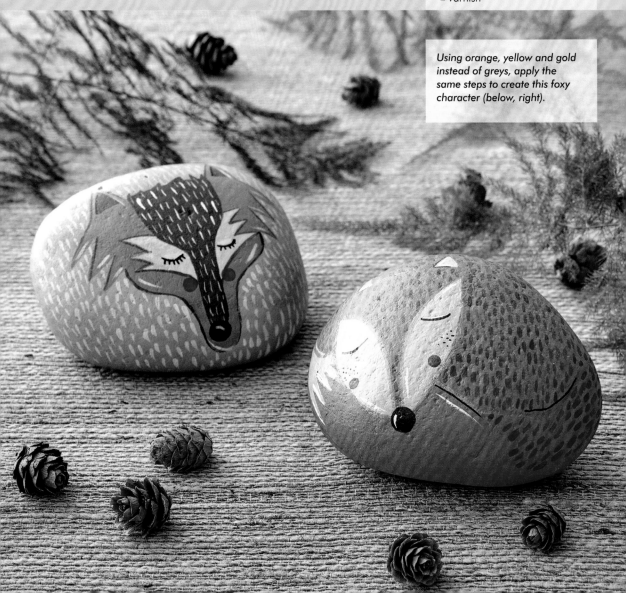

Using orange, yellow and gold instead of greys, apply the same steps to create this foxy character (below, right).

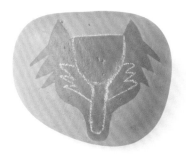

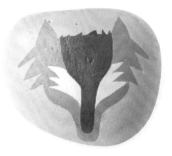

1 Find a flat, round pebble and clean it with a damp cloth. Apply two layers of light grey paint and, once your pebble is dry, sketch out the basic wolf shape with chalk.

2 Color in the wolf's face using mid-grey. Once dry, sketch out the snout and whiskers.

3 Apply dark grey paint to the top of the head and snout, and paint the whiskers white.

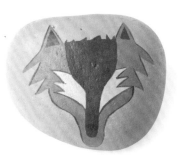

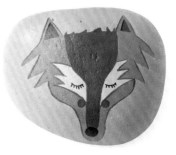

4 Using the dark grey paint and a thin paintbrush, outline the wolf's face and fill in the inner ears.

5 Use a thin black marker to add the eyes and nose, and red paint to create two rosy cheeks.

6 Use the white marker to add thin lines to the top of the head and the snout. Do the same on the background. Add white shadow lines around the wolf's ears and the edges of his face to give it movement. Varnish the pebble once the paint is dry.

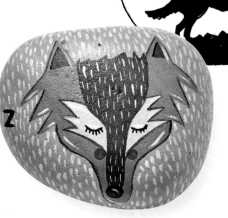

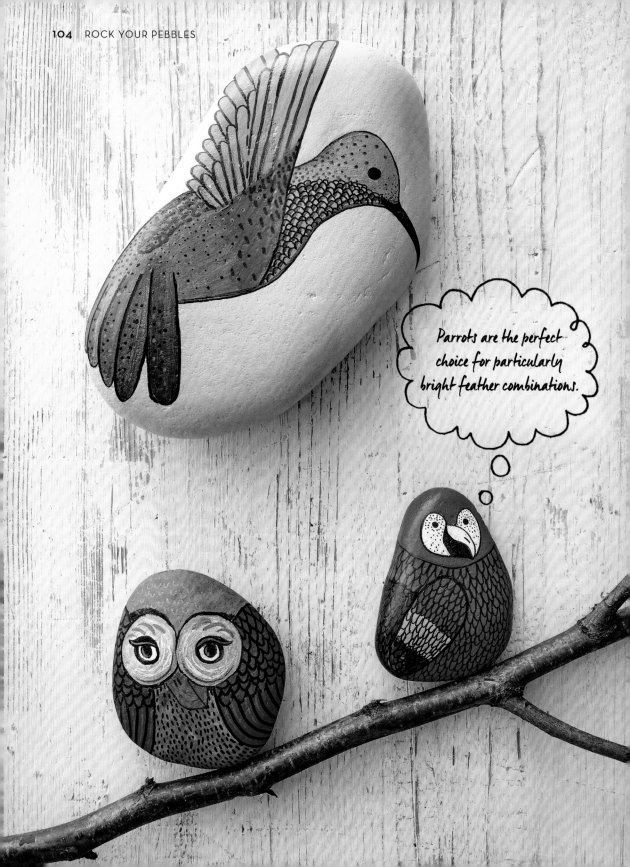

TROPICAL BIRDS

Birds provide the perfect opportunity to use your brightest paints and go wild with colour. Just add the feather texture over the top to keep them looking realistic.

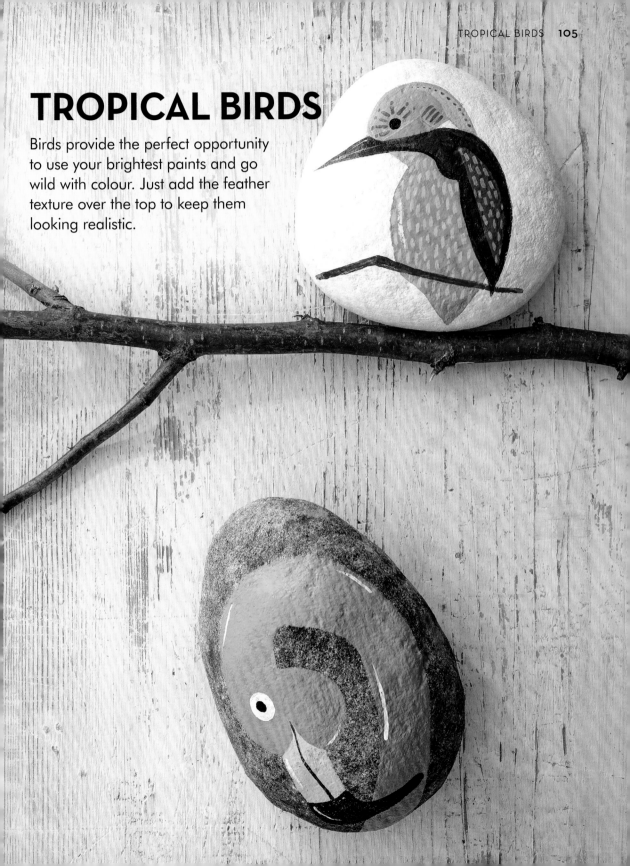

RAINBOW UNICORN

As beautiful creatures of legend, unicorns have a rightful place in your collection of pet pebbles. Bring on your most vibrant paints and add a touch of magic to this mythical beast.

YOU WILL NEED

- Flat pebble
- Damp cloth
- Chalk
- Paintbrushes
- Thin black pen
- Grey or silver pen
- Gold pen
- White, blue, green, purple and orange craft paint
- Varnish

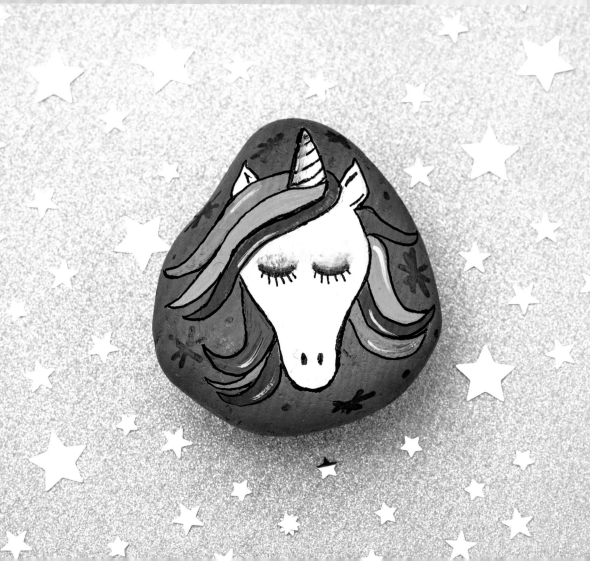

1 Pick your pebble and clean it with a damp cloth. Use chalk to sketch the basic form of the unicorn's head.

2 Paint the head and ears in white. Add a triangular shape between the two ears to create the horn.

3 Paint the background blue. When the paint is dry, use chalk to sketch the unicorn's hair.

4 Pick out your most vibrant paints and fill in each strand of hair with a different colour.

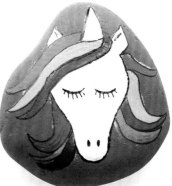

5 Outline the head, horn and hair with a black pen. Add two nostrils at the bottom part of the head and then add the closed eyes, complete with long eyelashes.

6 For the finishing touches, add lines to the horn and use the silver pen to create shadow. Use the gold pen to decorate the blue background with stars. When everything is dry, add a layer of varnish.

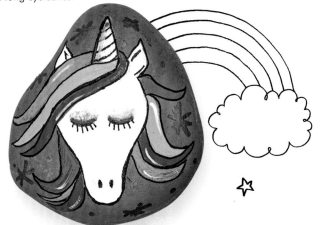

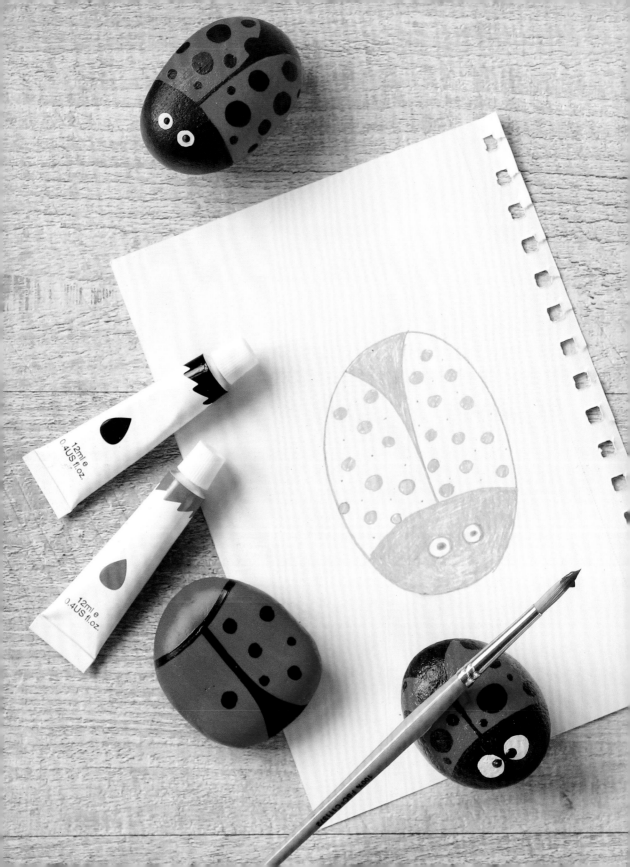

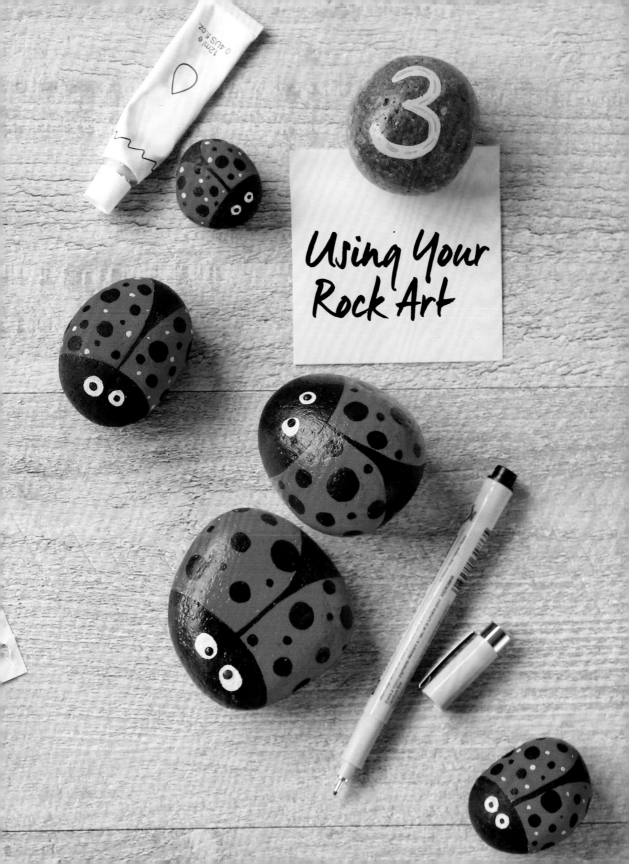

Using Your
Rock Art

Sleeping Hamster

Place your sleeping pet pebble close to you, where it won't be disturbed – this way you can keep an eye on your critter while it naps.

Party Table Weights

Add a special touch to your picnic with pet pebbles painted with party hats and bows. Place on napkins and paper plates, to help keep them on the table.

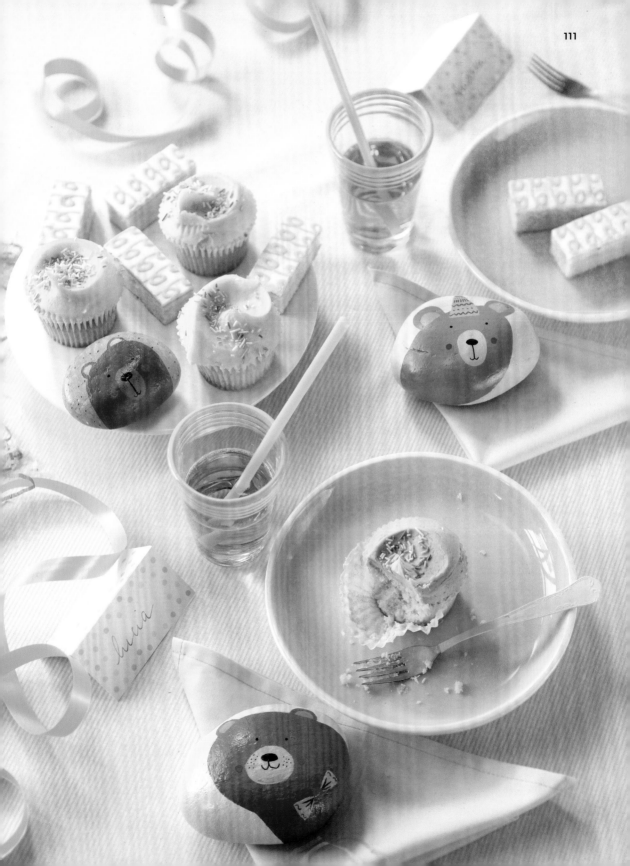

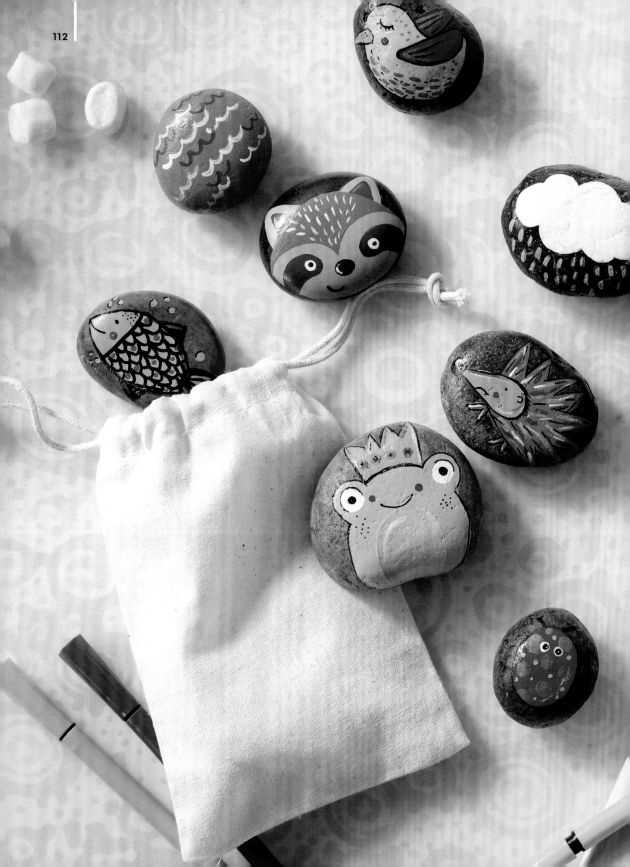

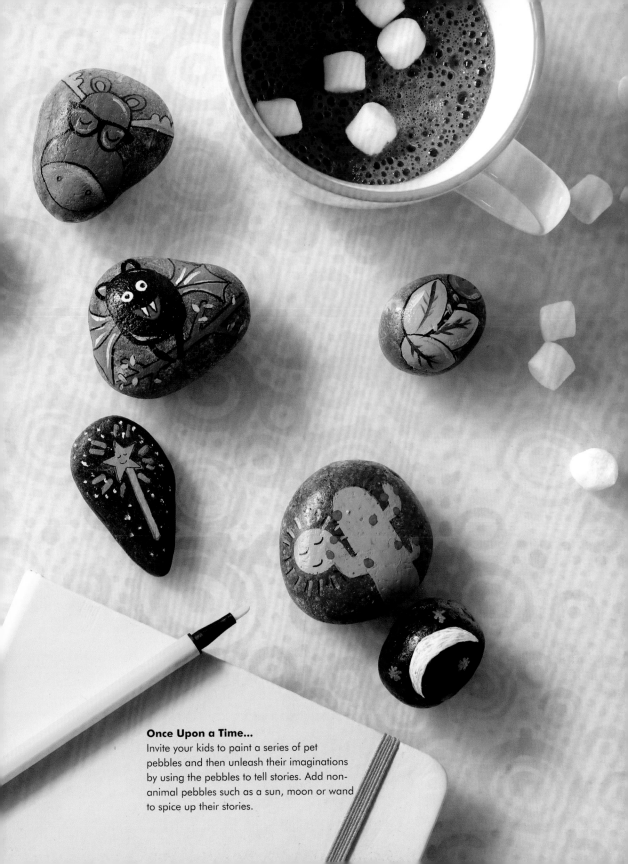

Once Upon a Time...

Invite your kids to paint a series of pet pebbles and then unleash their imaginations by using the pebbles to tell stories. Add non-animal pebbles such as a sun, moon or wand to spice up their stories.

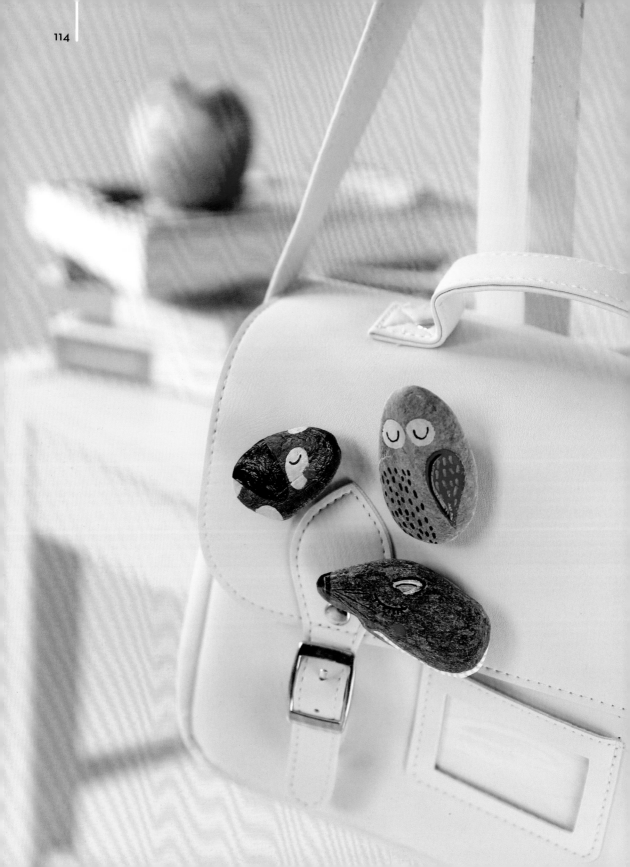

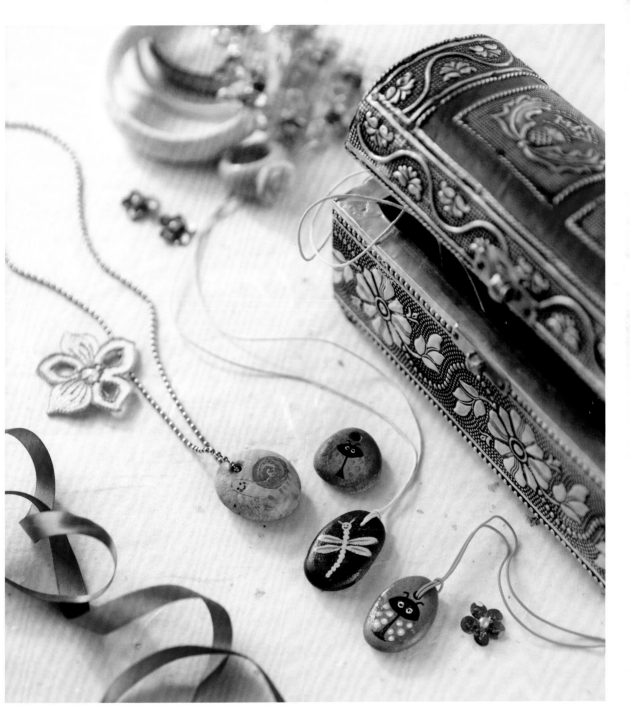

Critter Brooches

Use flat pebbles to design brooches that can be attached to handbags, jackets or T-shirts. Simply glue tiny pins to the back of your pebble, then take your pebble pets everywhere you go!

Little Friends Pendants

Choose a little critter, such as a bug, or upsize your pebble for a statement pendant featuring a larger animal. You can buy pre-drilled pebbles online!

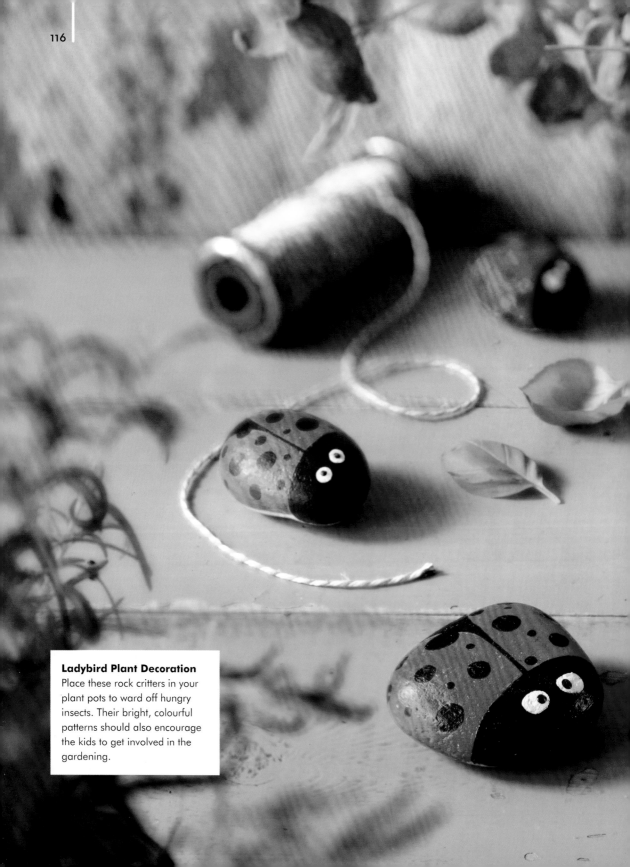

Ladybird Plant Decoration
Place these rock critters in your plant pots to ward off hungry insects. Their bright, colourful patterns should also encourage the kids to get involved in the gardening.

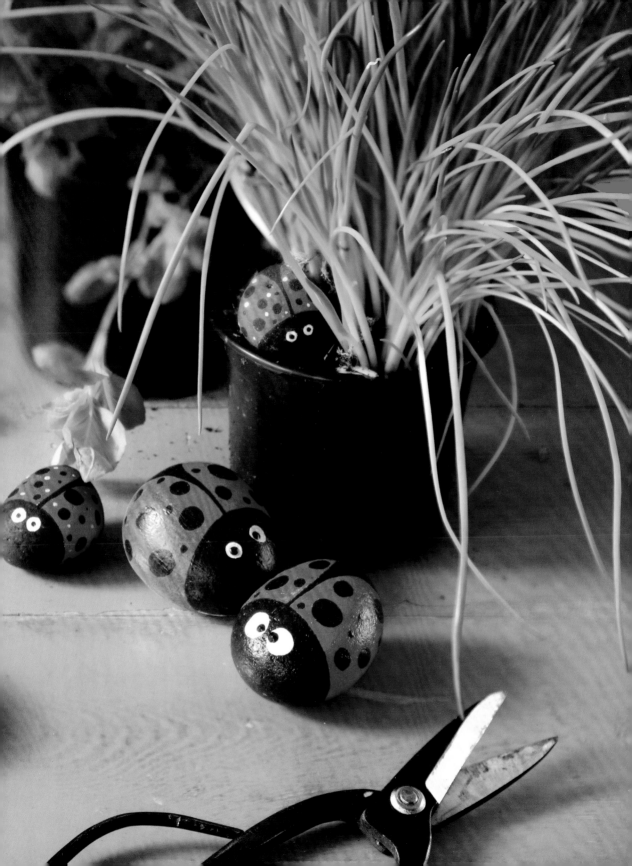

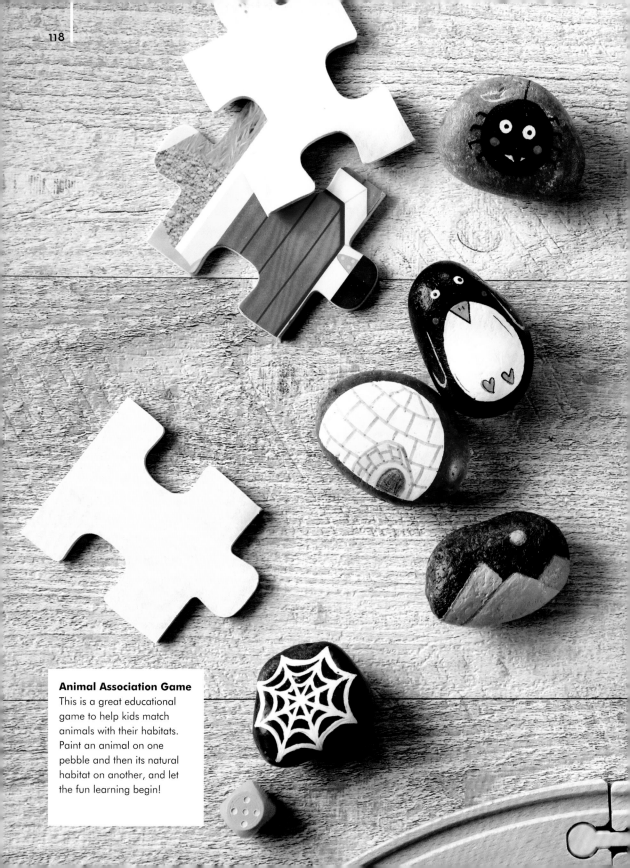

Animal Association Game
This is a great educational
game to help kids match
animals with their habitats.
Paint an animal on one
pebble and then its natural
habitat on another, and let
the fun learning begin!

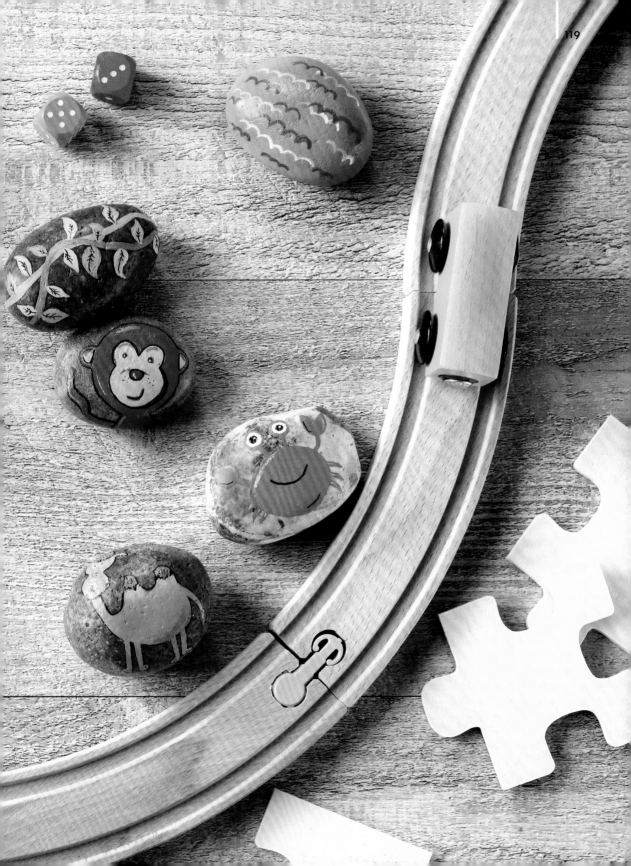

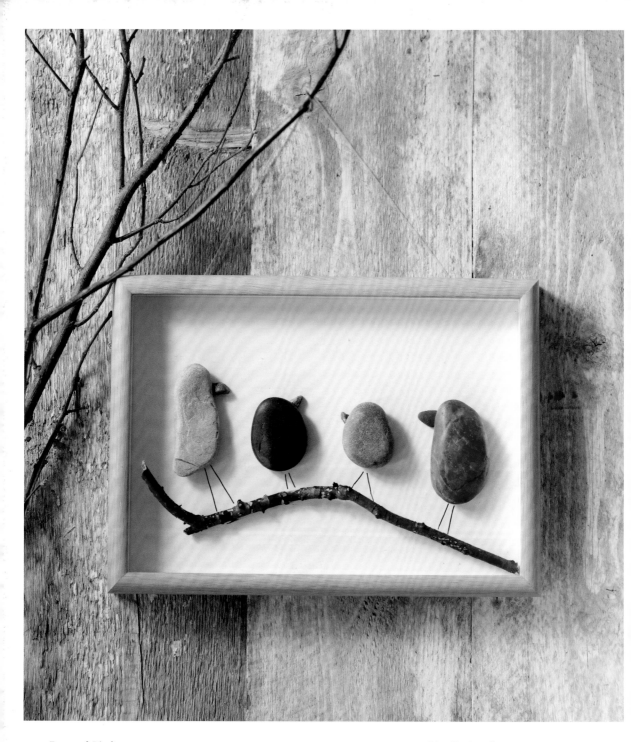

Framed Birds

Use the natural forms and textures of a variety of pebbles to make some birds, pop them on a twig, and frame in a natural-wood box frame for the perfect wall decoration.

Giraffe Puzzle

Play around with forms and shapes to come up with your very own animal pebble jigsaw.

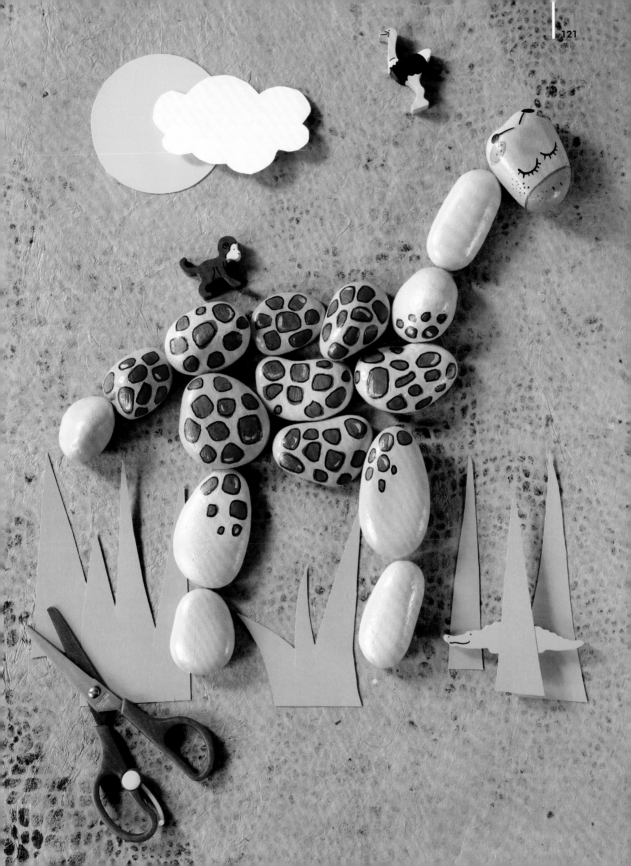

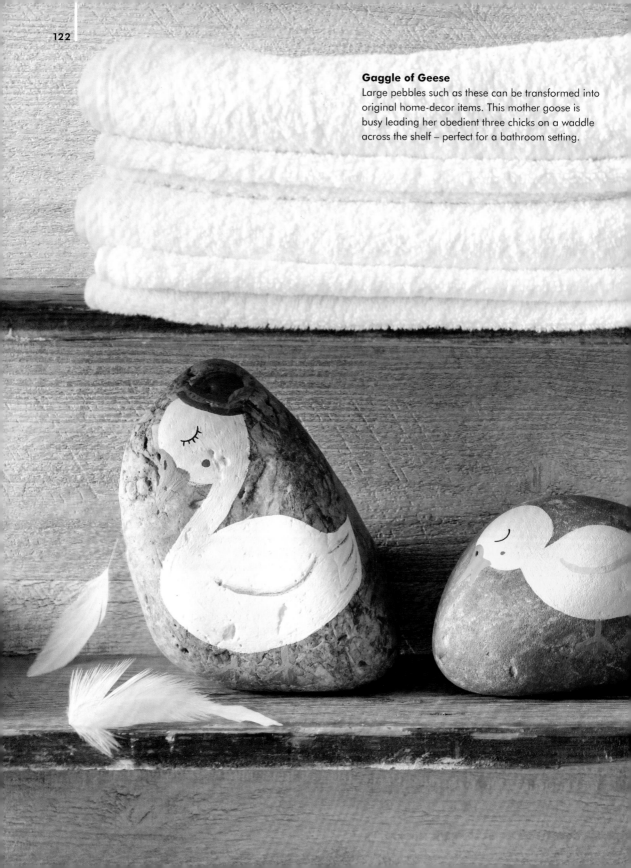

Gaggle of Geese
Large pebbles such as these can be transformed into original home-decor items. This mother goose is busy leading her obedient three chicks on a waddle across the shelf – perfect for a bathroom setting.

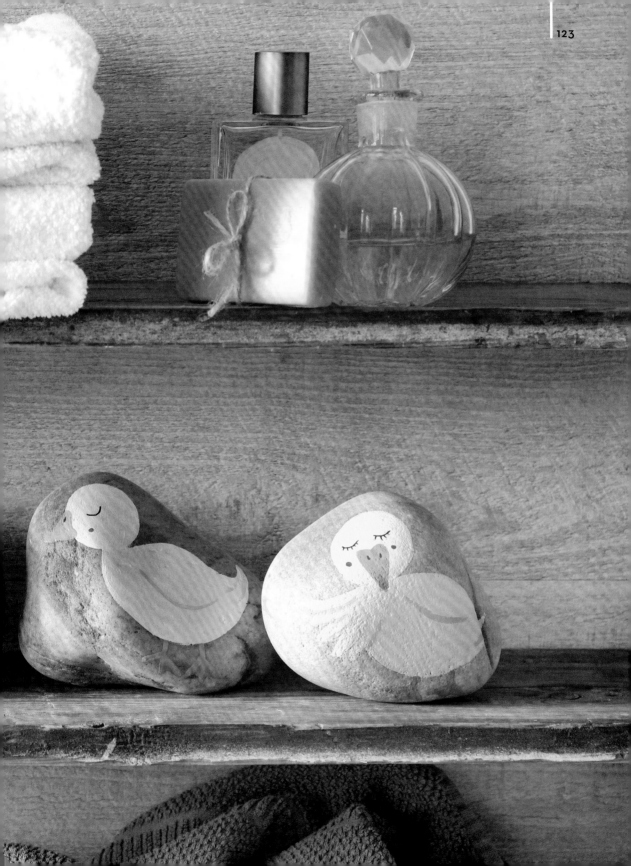

INDEX

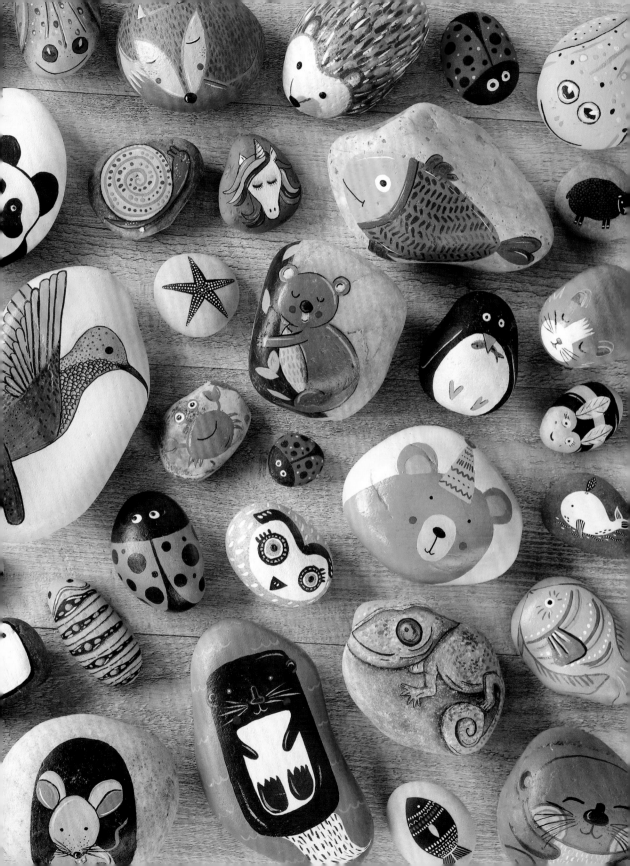

CREDITS

I would like to thank my two inspiring parents, my brother and sister for their support and encouragement, and my favourite human beings – Souleyman, Moira, Caroline, Roberto, Lotte, Ciara and Martin – for being wonderfully supportive and understanding throughout the making of this book.

The author and Quarto would like to thank Natasha Newton who supplied the rock art on pages 32–33, 42–43, 50–51, 58–59, 66–67, 76–77, 82–83 and 90–91. Learn more about Natasha at www.natashanewton.com.

Denise would also like to thank Souleyman Messalti (www.souleymanmessalti.com), who took the image on page 128.

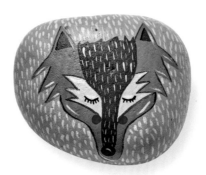